# And Not Afraid To Dare

## THE STORIES OF TEN
## AFRICAN-AMERICAN WOMEN

# Tonya Bolden

SCHOLASTIC INC.

New York  Toronto  London  Auckland  Sydney
Mexico City  New Delhi  Hong Kong  Buenos Aires

*In memory of my mother,*
*Georgia C. Bolden (1937–1989),*
*whose life story compels me to be brave.*

Page 146: Ulf Andersen, Gamma Liaison; page 188: AP/Wide World; page 92: Culver Pictures; pages 2, 128: The Granger Collection; page 166: NASA; page 32: Schomburg Center for Research in Black Culture; page 114: Terry Tierney; page 50: Rendering of Mary Fields by Angelo Tillery; page 64: University of Chicago.

If you purchased this book without a cover, you should be aware that this book is stolen property. It was reported as "unsold and destroyed" to the publisher, and neither the author nor the publisher has received any payment for this "stripped book."

No part of this publication may be reproduced in whole or in part, or stored in a retrieval system or transmitted in any form, or by any means, electronic, mechanical, photocopying, recording, or otherwise, without written permission of the publisher. For information regarding permission, write to Scholastic Inc., Attention: Permissions Department, 557 Broadway, New York, NY 10012.

ISBN 0-439-47139-7

Copyright © 1998 by Tonya Bolden.
All rights reserved. Published by Scholastic Inc.
SCHOLASTIC and associated logos are trademarks
and/or registered trademarks of Scholastic Inc.

12 11 10 9                                                    7 8/ 0

Printed in the U.S.A                                              40

First Scholastic Trade paperback printing, January 2003

Book design by Elizabeth B. Parisi

# Contents

## Interim

The night was made for rest and sleep
For winds that softly sigh:
It was not made for grief and tears:
So then why do I cry?

The wind that blows through leafy trees
Is soft and warm and sweet:
For me the night is a gracious cloak
To hide my soul's defeat.

Just one dark hour of shaken depths.
Of bitter black despair—
Another day will find me brave,
And not afraid to dare.

—Clarissa Scott Delany (1901–1927)

# To the Reader

I found this poem several years ago in a speech by "Sister President" Dr. Johnnetta B. Cole entitled "Let Another Day Find Us Brave." The occasion was her inauguration, in 1988, to the presidency of Spelman College, in Atlanta, Georgia.

Before Cole, this more than one-hundred-year-old historically black college for women had never had a black woman as its president. How reflective of the history of women of African descent in this country.

Invisible. Rejected. Shut out. Ignored. But it is a history, too, of climbing, stretching, striving.

Interim? It is an interval. It's that in-between time, that in-the-meantime. In Clarissa Scott Delany's poem, it is that heavy pause, that decisive moment between "Don't!" and "I Will."

Over and over again, during the course of our nearly four hundred years in this land, women of African descent have done amazing things against daunting odds. Through "grief and tears," through the

"soul's defeat," through waves of "bitter black despair," we have yearned and prayed that tomorrow would find us brave.

And not afraid to dare.

Here you will find portraits of ten women who braved prejudice, poverty, illness, family tragedies, and much hard work to be who they wanted to be. In finding and being themselves, they knowingly and sometimes unwittingly gave a lot to their people and to this nation.

Ellen Craft risked death to be free from slavery, and then worked for the liberation of others. Charlotte Forten Grimké jeopardized her health and gave up comfort to do her part in the "uplift of the race." Ida B. Wells faced death threats in her crusade against lynching. Mary McLeod Bethune spent her time, her money, and enormous amounts of physical and mental energies so that young minds could be freed from ignorance. Clara Hale gave up her retirement to heal and help very, very young lives. Toni Morrison has wielded words mightily to tell of the nightmares and glories of her people. Former opera singer Leontyne Price and former astronaut Mae C. Jemison defied conventional thinking and pursued careers that had been off-limits to African Americans for years. Even Mary Fields— that rather wild woman of the Old West—did her people (and Montana) proud, in a strange, humorous

way. And there's track-and-field champion Jackie Joyner-Kersee, who has taught us a great deal about running the distance.

The women in this book began as ordinary people. They did not sit bolt upright one day and proclaim, I will make history! But somehow, in their growing up and in their growing older something caught hold of their souls, hearts, minds. Something said, Do not be afraid to dare. And they listened; and they held fast to the feeling. And tomorrow found them brave.

—Tonya Bolden

# Ellen Craft

"One of the most interesting cases of the escape of fugitives from American slavery that have ever come before the American people, has just occurred."

So began a letter dated January 4, 1849, from escaped slave, abolitionist, and author William Wells Brown to his fellow antislavery activist William Lloyd Garrison. And Brown was not exaggerating. The story he went on to recount in this letter remains one of the most fascinating instances of a flight for freedom. It was a case of masterful illusion and artful dodges conceived and carried out by Ellen Craft, with major help from her husband, William.

To be a slave was to be regarded as a thing: to be worked from dawn to dusk beyond way past weary; to live under the constant threat of beatings. Even if the treatment was not the most severe, could that make up for being owned, totally and forever? For Ellen Craft, the answer was a resounding no!

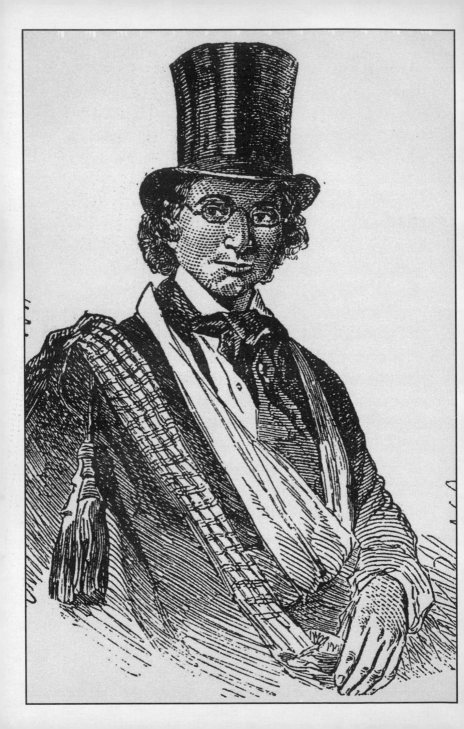

Ellen Craft's mother, Maria, was a very light-skinned woman whose father, it is believed, was her original owner. She later became the property of Major James C. Smith, a lawyer, land surveyor, and prosperous planter, who had earned his stripes in cavalry conquests of Native Americans in the Creek War. He was also one of the founders of Macon, Georgia, about ten miles south of his plantation in Clinton, where Maria was one of about a hundred slaves.

Like many enslaved women, forced labor and beatings were not the worst violation of body and spirit that Maria had to endure. At some point in her teenage years, Major Smith took a sexual liking to her. Maria was about seventeen when around 1826 she gave birth to Ellen, her first child by Major Smith. With hazel eyes, and hair that would grow to be very straight, and skin color and features showing no trace of her African blood, little Ellen could be easily mistaken for an Anglo-Saxon.

Ellen's appearance would one day be her means of deliverance from slavery; but during her childhood, it —along with her strong resemblance to her owner-father—meant extraordinary abuse from the major's wife. Hurt and angered by her husband's infidelity, Mrs. Smith took it out on young Ellen. She worked her especially hard, until the little girl almost dropped from exhaustion. She beat her often—with her words,

with her fists. Ellen had no protection from the cruel Mrs. Smith; Maria was powerless; and as for Major Smith, Ellen meant nothing to him.

Release from the tyranny of Mrs. Smith came when Ellen was about eleven years old, and Eliza, the eighteen-year-old daughter of Major and Mrs. Smith, got married. That's when Mrs. Smith found the perfect way to get Ellen out of her sight: The little girl became a wedding present to Eliza.

Ellen and Eliza were sisters: both the daughters of Major Smith, but there is no record of whether they ever talked about this strange kinship. All we know is that when Eliza—bride of Dr. Robert Collins, who owned a railroad, a bank, and ten thousand acres of land—rode off to her new home, a mansion in Macon, she did so with her little sister, her property now, in tow.

Eliza was not as mean to Ellen as her mother had been, and because she served as Eliza's personal maid, Ellen was spared the backbreaking work so many slaves had to do. Hers were such duties as sewing, helping Eliza get dressed and groomed, and attending to her needs during meals. Ellen was apparently quite diligent and dutiful, for eventually she was given a one-room cabin all to herself, behind the Collinses' mansion.

Life was indeed a bit better for Ellen now, and when, at around age twenty, she met a man very much

to her liking, a little joy seeped into the sorrows of her enslavement. This man was William Craft and he, too, was a slave.

When Ellen met William, his family had long been split up. His parents had been sold when he was young because, as he wrote years later, "they were getting old, and would soon become valueless in the market, and therefore [the master] intended to sell off all the old stock, and buy in a young lot." William and his brother were apprenticed to local craftsmen so their owner could rent them out as skilled workers and make more money. When a bad investment left this man scrambling for money to pay off huge debts, he began selling slaves again. William, his brother, and their fourteen-year-old sister were sold to different people. William was purchased by a cashier in the bank owned by Eliza's husband and Ellen's co-owner, Dr. Collins. This cashier, Ira H. Taylor, rented William out to a carpenter. From the small portion of the rental fee his master allowed him to keep, and from occasional work at a restaurant, William was able to save a little money.

Ellen fell in love with William, but she was resistant to taking a mate. If she did, she'd very likely have children, who would also be slaves; and Ellen had vowed never to bring another human being into bondage.

Ellen and William sometimes thought about escaping. But how would they do it? They were in the Deep

South, where there were no "stops" on the Underground Railroad. Trekking all the way north on their own would be a long, perilous journey. Ellen and William knew that if they were caught, separation, torture, or possibly death would be their punishment. As William would later write:

> [A]fter puzzling our brains for years, we were reluctantly driven to the sad conclusion, that it was almost impossible to escape from slavery in Georgia, and travel 1,000 miles across the slave States.

In 1846 Ellen and William sought their owners' permission to marry. Their request was granted, and they tried to make the best of life as husband and wife. They honored Ellen's vow not to have children.

But they did not abandon all hope of freedom. "*Almost impossible* to escape," is what William had said. The Crafts, both God-believing people, continuously prayed for a way out.

Their prayer was answered in the form of an ingenious plan. It was inspired, no doubt, by a story Ellen had heard as a child about a mulatto cousin, named Frank, who could pass for white, and who, after making his way to the North, used his white color to return to the South and reunite with his siblings. Just like her cousin, Ellen could pass for white—and so,

the Crafts first thought to strike out from Georgia with Ellen posing as a white lady . . . traveling with her slave!

But then came the realization that this wouldn't work. It was highly unusual and considered improper for a white woman to be traveling with a male slave—unless he were very old, infirm, or lame. William was robust and, like Ellen, in his early twenties. Of course, it would not be so odd for a white woman to travel with a female slave, but William could hardly disguise himself as a woman. But . . . could Ellen be transformed into a man?

Over time, William went about securing a gentleman's outfit, item by item: a black cloak, a white dress shirt, an ascot, a beaver stovepipe hat. The black trousers Ellen made herself and secreted away, along with the other elements of her disguise, in a small chest of drawers her husband had made.

But how could they steal away without being immediately missed? They decided to wait until Christmastime, when slave owners were likely to be a bit gracious and security was a little lax. Full of holiday cheer, slave owners often allowed their property to visit friends or relatives on a nearby plantation. Both Ellen's and William's owners gave them permission and the necessary passes to be away for a few days, and soon the Crafts were ready. But as the hour of their flight drew

near, Ellen was overcome by a whirlwind of what-ifs?

What if she, as yet unable to read or write, were asked to sign a register during the course of their travels? What if, man's clothing and all, her feminine face made people examine her closely? If she were drawn into conversations with her fellow travelers, might not her voice give her away? And what if her eyes reflected the fear that would surely have her heart pounding? Just being a young white gentleman wouldn't do. It wasn't safe enough.

But a young white *sickly* gentleman might do it.

They decided to put Ellen's arm in a sling to excuse her from any writing. A bandage would be tied around her face to mask and distort her features and discourage conversation. To conceal any fear in her eyes, William purchased a pair of eyeglasses with lenses of green glass.

After a haircut, Ellen was fully transformed into one William Johnson, a rather pathetic but proper young white gentleman, suffering from "a complication of complaints," as William Craft would later tell one inquirer. This frail young man was traveling with his trusty servant to seek medical treatment in Philadelphia, Pennsylvania.

Thus the Crafts entered the Georgia night and began that thousand-mile journey with the money they had saved over the years and a prayer on their lips. It

was now or never. William would one day relive this critical moment with these words:

> We then opened the door, and stepped as softly out as "moonlight upon the water"... and tiptoed across the yard into the street. I say tiptoed, because we were like persons near a tottering avalanche, afraid to move, or even breathe freely, for fear the sleeping tyrants should be aroused, and come down upon us with double vengeance, for daring to attempt to escape. . . .

They knew it wouldn't be long before their owners realized they had run away. To reduce the possibility of capture, instead of taking a train directly to Philadelphia, the Crafts had planned a more roundabout journey, which would have them changing modes of transportation a lot, making it harder for a slave hunter to track them down.

Truly, they had planned their escape route well, yet at almost every turn of their four-day journey, the Crafts had a scare. Shortly after they boarded a train bound for Savannah, Georgia, William spied the carpenter for whom he worked, standing on the platform, talking to the ticket-seller, looking over the passengers aboard the train. Had he suspected that something was afoot? For a minute William was certain the man was going to get on the train, but then a bell rang, signaling

the train's departure, and the carpenter did not get on-board.

But a Mr. Cray did. He was acquainted with Ellen's owners, and had, in fact, dined with Eliza and Robert Collins just the day before. And he was seated in the same car as Ellen.

Ellen kept her face turned away from Mr. Cray. When he tried to engage "Mr. Johnson" in conversation, she pretended to be deaf, and he soon left her alone. Ellen did not breathe easy, however, until Mr. Cray got off the train not many miles later.

When the Crafts arrived in Savannah hours later, they took an omnibus to a steamboat soon to sail for Charleston, South Carolina. Onboard, while William had to sleep on the deck, Ellen had a relatively comfortable berth. She would need all the rest she could get, because the next day she would be dealing with some very meddlesome people.

It started with the ship's captain warning "Mr. Johnson" that his slave might try to escape when he arrived in Philadelphia. On the heels of this, a "hard-featured, bristly-bearded, wire-headed" passenger also warned the young gentleman that he might lose his slave once they crossed the Mason-Dixon line, and then he offered to buy William for "hard silver dollars." A little later, a military officer, noticing that "he"

was rather civil to his manservant, urged "Mr. Johnson" to be more harsh, lest he spoil him. Ellen said little. She nodded a lot in agreement, and prayed silently all day.

In Charleston the Crafts boarded another steamboat, this one bound for Wilmington, North Carolina. Here they met their first huge challenge: "Mr. Johnson" was asked to sign the register. Pointing to the sling, "he" asked the clerk to do the writing for him. The clerk refused. Luckily, the military officer from the last boat was close by, and this time Ellen was glad he was so meddlesome. He vouched for "Mr. Johnson." The officer's uniform and the fact that he was known in Charleston carried much weight. The ship's captain registered "Mr. Johnson and slave" himself.

In Wilmington the Crafts traveled again by rail to the Virginia coast. Here, they caught a steamboat to Washington, D.C. There, they met another train bound for Baltimore, where they were stopped dead in their tracks.

The Mason-Dixon line was the boundary between Maryland and Pennsylvania—and much more. It was the symbolic line between slavery and freedom: Maryland was the northernmost slave state on the East Coast; Pennsylvania, the southernmost eastern state where slavery was illegal.

After helping his master into the train, William headed for the car for people of color and baggage. But on the platform, a station officer stopped William and began to interrogate him. When this officer found out that this slave and his master were on their way to Philadelphia, he told William to have his master make haste to the office to speak with his supervisor. The Crafts felt doomed, but what could they do?

"It is against our rules, sir," said the arrogant supervisor, "to allow any person to take a slave out of Baltimore into Philadelphia, unless he can satisfy us that he has a right to take him along." As he continued his speech on company policy he explained: "if we should suffer any gentleman to take a slave past here into Philadelphia; and should the gentleman with whom the slave might be travelling turn out not to be this rightful owner; and should the proper master come and prove that his slave escaped on our road, we shall have him to pay for; and, therefore, we cannot let any slave pass here without receiving security to show, and to satisfy us, that it is all right."

More than a few white abolitionists had helped people escape slavery by sneaking them out of the South as their property. Baltimore was the last and, therefore, the most important checkpoint.

Ellen and William had come this far by faith, and a lot of good fortune. They were at the end of their

strength, running out of hope that they would complete that thousand-mile journey. Ellen had been under the greatest strain. She'd had to manage the masquerade, summoning up every memory she had of the ways of upper-class Southern white folk, in conversation, in taking meals, in handling railroad and steamboat officials. Most painful of all, she'd had to treat her husband like a slave and remain silent and seemingly serene when others abused their servants or expressed their contempt for people of African descent. And now, after they had made it this far, freedom seemed a million miles away.

Ellen dug deep—for strength, for composure, for the ability to respond as a Southern gentlemen would. When she finally spoke, she played the part very well. "Mr. Johnson" got quite indignant, protesting that because he had purchased tickets in Charleston for passage straight through to Philadelphia, they had no right to detain him. "Right or no right," said the railroad official, "we shan't let you go."

The silence was heavy and long. In recounting it years later William wrote:

> [Ellen] looked at me, and I at [her], but neither of us dared to speak a word, for fear of making some blunder that would tend to our detection. . . .
> While our hearts were crying lustily unto Him who is

*ever ready and able to save, the conductor of the train that we had just left stepped in.*

The conductor confirmed that "Mr. Johnson" had been on his train from Washington, D.C. This, along with the sounding of the final all-aboard bell, pressured the man to give up his scrutiny and allow the young gentleman and his slave to continue their journey.

At Havre de Grace, Maryland, the Crafts ferried across the Susquehanna River, where they boarded the train whose next stop was Freedom.

These must have seemed the longest miles.

"Thank God, William, we are safe!" Ellen exulted through tears when she and her husband set foot on Philadelphia soil on Sunday, December 25, 1848— Christmas Day.

The Crafts lodged at a boardinghouse that William had been told about by a man he had met on the train. This man had urged him to run away, echoing another fellow who had prodded William to "leave that cripple, and have your liberty."

Liberty was just what William and Ellen now had. And they would have help making a new life, because the boardinghouse belonged to abolitionists, who

promptly sent word of the Crafts' arrival to their associates. It was not long before the Crafts had some very important friends. Among them was freeborn Robert Purvis, one of the founders of the American Anti-Slavery Society and a member of the Pennsylvania Anti-Slavery Society's executive committee; William Still, a chief operator of the Underground Railroad, who was also born free; and the very famous escapee from slavery, William Wells Brown, who was in Pennsylvania at the time for an antislavery conference and lectures.

After a short time in Philadelphia, the Crafts were sent for rest and sanctuary to Barclay and Mary Ivins, on their farm in Bucks County, about twenty miles north of the city. Among the many kindnesses this Quaker couple showed the Crafts was teaching them to read and write. Ellen and William were not illiterate by choice. They had learned the alphabet in Georgia, but that had been as far as they had gotten. It was illegal to teach slaves to read and write, with punishment ranging from a fine to imprisonment to death, depending on the race of the teacher. For the student, the penalty was almost always a severe beating, if not worse.

At the end of their stay with the Ivins family, the Crafts could confidently write their names and were on their way to better reading and writing skills, which

would also improve their speech. This would definitely come in handy when they reached their next city of refuge, Boston, Massachusetts.

At the outset of their flight, the Crafts had planned on making Canada their final destination. Many runaways had opted for Canada (the last stop on the Underground Railroad) because slavery had been abolished there in 1831. Although it also had been abolished in the Northern United States, no runaway was truly safe in the North. The Fugitive Slave Act of 1793 gave slave owners the right to retake their property wherever it was found, even in the North. Nonetheless, the Crafts' Philadelphia friends convinced them that Boston would be safe because slave hunters did not have an easy time in Massachusetts. Granted, there were many proslavery people in this state, but antislavery sentiments and activities were very intense.

Boston was home to the tireless William Lloyd Garrison, founder and editor of the newspaper *The Liberator*, and founder of both the American Anti-Slavery Society and the New England Anti-Slavery Society. Two of Boston's other leading white abolitionists who would be of tremendous help to the Crafts were lawyer Wendell Phillips and the Reverend Theodore Parker.

Equally if not more important for the Crafts' emotional well-being was the fact that Boston had a sizable

population of people of African descent. And as one historian put it, "for many black Bostonians, social protest was . . . a family tradition." One example was Thomas Paul, founding pastor of the African Baptist Church, whose daughter Susan was a member of the Massachusetts Anti-Slavery Society, and whose son Thomas Paul, Jr., the first black graduate of Dartmouth University, was a teacher and later headmaster at the African School. It was in Boston that, in 1829, David Walker, a Malcolm X of the day, penned his pamphlet known as the *Appeal*, a scathing attack on slavery and a radical call for black independence and self-reliance.

Boston had also become home for William Wells Brown, whom the Crafts had first met in Philadelphia. It was he who introduced the Crafts at their first public appearance on January 24, 1849. The occasion was the Massachusetts Anti-Slavery Society's annual conference at the legendary Faneuil Hall, which in Colonial days was a meeting place of anti-British activists involved in several major events that led to the Revolutionary War. Antislavery Bostonians referred to this place as "our own cradle of liberty."

At Faneuil Hall, the Crafts were quite a sensation. They were overwhelmed by the applause of a crowd that had been eagerly awaiting them. William Wells Brown's letter to William Lloyd Garrison—about "one

of the most interesting cases of the escape of fugitives from American slavery" —had been reprinted in *The Liberator* about two weeks earlier, and several other newspapers had picked up the story and run articles on the Crafts. In no time at all, under Brown's direction, the Crafts were on a four-month speaking tour to more than sixty towns, telling their story and pleading the cause of the roughly three million men, women, and children in bondage. In his biography of Brown, William Edward Farrison offers a sketch of a typical meeting:

> *First . . . Brown introduced Craft, who recounted his and his wife's lives as slaves and their escape from slavery. . . . Next Brown delivered a speech. . . . After this he introduced Mrs. Craft, who sometimes added a few words to what her husband had said. . . . Finally a collection for the antislavery cause was taken, abolition publications were offered for sale, and the meeting was adjourned.*

Though she had been the pivotal, critical player in their escape, Ellen Craft was now relegated to the shadows. This had less to do with her shyness than with the fact that it wasn't customary for women to engage in public speaking. In time, Ellen did speak more, as more and more white people demanded it. It wasn't that they thought she was a better speaker than William, but

they were fascinated by her appearance and her color. They seemed to be more attracted to and to have more sympathy for Ellen, because she looked like them.

The Crafts' popularity on the antislavery lecture circuit also had its dangerous side. The newspapers advocating the abolition of slavery were not the only ones to pick up their story. Not long after their arrival in Boston, Macon's *Georgia Telegraph* ran an article about the Crafts that had appeared in a New England paper. "The Mr. and Mrs. Crafts who figure so largely in the above paragraph," read the editor's note, "will be recognized at once by our city readers as the slaves belonging to Dr. Collins and Mr. Ira H. Taylor, of this place, who [ran away] or were decoyed from their owners in December last."

When the Crafts heard about this article they were not too fearful, knowing that slave hunters were despised by many of Boston's citizens and received little assistance from the city's law enforcement officials. So they made no plans to leave (or cut back on lecturing), but settled down in relative peace at a boardinghouse run by Lewis and Harriet Hayden. The Haydens, once enslaved themselves, were agents for the Underground Railroad and members of the Freedom Association, which had been formed to provide all kinds of help to people who escaped slavery.

To support themselves, William worked as a carpenter, soon opening a furniture store, and Ellen worked as a seamstress, eventually expanding into upholstery. The Crafts were, for the first time in their lives, truly free—economically independent. But their security and peace of mind did not last long.

Their liberty was seriously threatened in late 1850 when President Millard Fillmore signed the new Fugitive Slave Law. This bill, part of the Compromise of 1850, was one of the concessions the North made to squelch the talk of secession going on in the South since the 1840s.

Under this new, harsher act, federal marshals were obligated to assist in the capture of people who made it to the Northern states. When a case was taken to court, fugitives were denied the right to a jury or to testify. In addition, judges who ruled in favor of the alleged owner would receive ten dollars, whereas those who ruled in favor of the alleged slave would receive five. Those who helped fugitives escape recapture could be fined as much as two thousand dollars and imprisoned for six to twelve months. Armed now with a fugitive slave law with bite, slave owners unleashed a bounty of slave hunters on the North.

When two men showed up in Boston hunting for the Crafts, Ellen and William went into hiding. At first their friends thought they could keep them safe until

the men left or were run out of town. The Committee of Vigilance and Safety (CVS), established for this crisis, kept the men under surveillance, harassing them all the while. But it would take more than the CVS to keep the Crafts from being captured. Dr. Collins, husband of Ellen's sister—mistress, appealed to the president for help, and President Fillmore made plans to give it to him. Of those wretched days, the Reverend Theodore Parker, who helped the Crafts in their hiding out, wrote in his journal: "Talk in the newspapers about the President sending on 600 or 700 soldiers to dragoon us into keeping the Fugitive Slave Law!"

At first Parker and others considered standing their ground in protecting the Crafts, even against the army. But in the end, all parties agreed that getting them out of the United States would be the wisest course of action.

Canada was the closest option. But it was for England, where slavery had been abolished in 1833, where Parker and others had friends, and where William Wells Brown was living at the time, that the Crafts departed. And so in the late fall of 1850, two years after their first flight, Ellen and William Craft were once again on the run.

Theirs was an arduous stop-and-go journey. They went first to Portland, Maine, then to St. John, in New Brunswick, and then to Windsor and Halifax, in Nova

Scotia, finally landing in Liverpool, England, in December 1850. It had been a trek fraught with ship delays, a stagecoach accident, and foul treatment from some of the people they encountered along the way. Ellen weathered all this as best she could, but arrived in Liverpool an emotional and physical wreck.

In Liverpool the Crafts found respite with the Reverend Frances Bishop and his wife. When Ellen was feeling better, the couple sent their letters of introduction from their Boston benefactors to journalist Harriet Martineau, who lived in the Lake District of northwest England, and to the esteemed Dr. John Estlin, of Bristol, in the southwest. Both had the Crafts stay in their homes for a while; and both would be their entrée into the British antislavery world. However, before the Crafts made their London debut, William Wells Brown whisked them away for speaking engagements in Scotland—in Edinburgh, Glasgow, Dundee, Aberdeen, and Melrose. By April 1851 the Crafts were back in England, settling down in London.

The public appearances didn't stop and the Crafts were almost constantly traveling in high society circles. As Dorothy Sterling explained in her book *Black Foremothers*, the British antislavery movement was made up of "the best people": lords and ladies, members of Parliament, prominent ministers, physicians, writers,

and such. In fact, the president of England's Anti-Slavery Society was Prince Albert, Queen Victoria's husband. Thus, on their lecture tours the Crafts were often put up in elegant hotels or country homes. Almost always they spoke in large halls before thousands of people.

What of their life beyond the cause of freedom?

With the help of a friend the Crafts were given a home in the village of Ockham, on the outskirts of London. Here, they attended the Ockham School, which offered instruction in the three Rs and such trades as farming, carpentry, and printing. The Crafts paid for their education by working as teachers, with Ellen giving instruction in sewing, and William, in carpentry.

And while they were making a living, they were also making a family. In October 1852, Ellen gave birth to a son: Charles Estlin Phillips Craft, named after men who had helped the Crafts procure their liberty. Charles was the fulfillment of the vow Ellen had made. Her child was born free.

Around this time there was a rumor that Ellen Craft was wretched in England—so wretched that she begged an American visiting London to help her get back to the United States, and to the people who still claimed her as their property. This story had made its

way even into the newspapers. In response, Ellen wrote a letter that was published in several antislavery newspapers, both in England and the United States. Her letter read, in part:

> So I write these lines merely to say that the statement is entirely unfounded, for I have never had the slightest inclination whatever of returning to bondage; and God forbid that I should ever be so false to liberty as to prefer slavery in its stead. . . . I had much rather starve in England, a free woman, than be a slave for the best man that ever breathed upon the American continent.

About a year after their son's birth, the Crafts moved to London to truly make a life of their own, to get out from under the shadow of their benefactors. Their first venture was a boardinghouse. When this was unsuccessful, William went into the import business. He had more success here—enough to buy a home, in Hammersmith, a suburb of London, and to support nicely a family that soon would be larger by four: after two more boys, William, Jr., and Brougham, came little Ellen, and then Alfred.

By the early 1860s the Crafts had settled into a fairly normal life. They did not, however, abandon the cause. William and Ellen had been at work on getting

their story down on paper, to serve as more ammunition in the campaign to end slavery in the United States. This most unusual travelogue, *Running a Thousand Miles for Freedom*, was published in 1860.

Like her husband, Ellen Craft was soon envisioning freedom for millions as a real possibility when she heard about the outbreak of a civil war in the United States in early January 1861. And how she must have wept with joy when word came that on January 1, 1863, President Abraham Lincoln issued the Emancipation Proclamation, which freed slaves in rebel territory. Surely, Ellen Craft shed more tears of jubilation over the news that on February 1, 1865, Lincoln had approved the Thirteenth Amendment, which declared: "Neither slavery nor involuntary servitude, except as punishment for crime . . . shall exist within the United States." The amendment was considered in full effect that April when at Appomattox, Virginia, the Confederate Army's General Robert E. Lee surrendered to the Union's General Ulysses S. Grant. It was essentially the end of the Civil War.

Ellen Craft knew her people would need help in making new lives. She did her share, from working with the British and Foreign Freedmen's Aid Society to working on fund-raisers. Friends in the United States, chief among them Wendell Phillips, helped her find

her mother. Maria was in Macon, "in good health, very hale," she was told. Ellen sent money and made plans for her mother to join her in England, which Maria did in November 1865.

It was a letter from their friend Lewis Hayden in Boston that left Ellen, more so than William, with a deep desire to return to the United States. Hayden reported on the good work being done under Reconstruction. The news filled Ellen with great expectations.

The federal Freedmen's Bureau was in charge of the herculean task of seeing to it that people of African descent had equal opportunity in all realms of life. Feeding, clothing, sheltering people; setting up hospitals and schools; parceling out abandoned, confiscated, and government land for sale and rent; helping people relocate and find their relatives—these were among the aid and services the Freedmen's Bureau offered some four million former slaves (and some needy white people, too). Reconstruction also gave African-American men the opportunity to be public servants—as municipal, city, and state officials, and congressmen.

Ellen Craft so wanted to be a part of the birth of this new nation, where with the passage of the Fourteenth Amendment in 1868, people of African descent became citizens. It wouldn't be long before William Craft would be ready to go home.

The Crafts arrived in the United States in 1869. Boston was their first stop and where they stayed for a while, becoming reacquainted with old friends and getting their bearings. They had left as hunted runaways. They returned as legally free people. They had been away for almost twenty years.

By 1871 the Crafts had settled down in their old home state of Georgia. With their savings and contributions from friends and supporters, they purchased an 1,800-acre plantation in Ways Station, about twenty miles south of Savannah. On it, they and their tenants grew rice and cotton. The Crafts also started a school: the Woodville Co-Operative Farm School, modeled after the Ockham School, in England. William was very active in Republican politics, even running for office once. Since his political work and business ventures often took him away from home for long periods of time, it was Ellen who essentially managed the farm and the school

There is a description of Woodville in a letter William wrote to the *Boston Advertiser* in July 1875:

*Our schoolhouse is a frame building 30 by 40, one-and-a-half story. . . . The whole house being whitewashed, looks well for one of its kind. . . . There are seventy-five boys and girls on our books, most of whom attend regularly. . . .*

*Eighteen months ago only eight or ten of the children that now attend the school knew the alphabet, but now the most of them can read and write quite intelligibly. . . .*

*Nearly without compensation, my wife and sons have worked very hard to get the children on.*

Ellen Craft would continue to work very hard in the coming years, but sadly, the Crafts eventually were forced to abandon Woodville. A plantation was a costly enterprise. The Crafts' debts kept rising, and relief was nowhere in sight. It didn't help that the financial panics in the early 1870s sent the price of cotton tumbling down and the nation into a depression. What's more, the reign of terror in the South was intensifying.

Since the dawn of Reconstruction many white Southerners had worked to destroy it, and to restore white domination. Most of the Southern states enacted Black Codes, which limited the mobility of African Americans, barred them from certain trades, and concocted rules for employer-employee relations that rendered them virtually slaves again. In 1866 the Ku Klux Klan had formed, sparking the formation of other terrorist groups committed to white supremacy. The final blow came in 1877, when in order to win Southern votes, Republican candidate Rutherford B. Hayes agreed that if he were elected president, the North

would not meddle in the South's affairs. Hayes *was* elected, and made good on his promise. The first thing he did was pull out the troops that had been stationed in the South to keep the peace, and to keep former slave states from sabotaging Reconstruction projects. With the troops gone, much of the social and economic progress African Americans had made was lost.

Around 1890 the Crafts left Georgia and moved to Charleston, South Carolina, where their son Charles and their daughter, Ellen, lived. The elder Ellen Craft died sometime in the early 1890s; William, a few years after his wife. While historians disagree about the exact date of Ellen's death, there is no doubt that she lived out her last days in relative comfort in the home of her daughter and son-in-law, Dr. William Crum, who served as a government official in Charleston and in 1910 became minister resident and consul general of Liberia in West Africa.

As for Ellen Craft Crum, she did her parents proud. She was active on Charleston's social and civic scene before she moved to Liberia. Also, she was one of the founders and the first vice president of the National Federation of Afro-American Women, formed in 1895—a merging of more than fifty groups from fourteen states and Washington, D.C., dedicated to the advancement of African-American women and the overall uplift of their race.

# Charlotte Forten Grimké

Charlotte Lottie Forten Grimké was not only born free, she was born into wealth and privilege. She grew up well-fed, well-clothed, and fairly well-sheltered from raw racism at 92 Lombard Street, her family's palatial home in Philadelphia, Pennsylvania. Charlotte's beginnings made her a prime candidate for being selfish and self-indulgent, and for setting her sights on a life of ease and leisure to the extent possible for a person of color in those days. But Charlotte wasn't born with a frivolous or lazy bone in her body. She came from formidable stock.

Her freeborn grandpapa, James Forten, served in the Revolutionary War as a powder boy aboard the Continental army's *Royal Louis* and was, for a time, a prisoner of war in England. After his release he returned to his native Philadelphia, but soon left for England in disgust. The treatment of his people by the new nation for which he had risked his life was too

much for him to bear. In England, his encounters with abolitionists transformed his rage into organized protest. He returned to Philadelphia around 1782, ready to make his fortune and get involved with his people's plight. The first he achieved by working his way up from an apprentice to a sail maker named Robert Bridges to being foreman of the company. James Forten so impressed his employer with his ambition and diligence that when Bridges retired in 1798, he lent him the money to buy his business. Forten had no problem repaying the loan. His business grew and thrived, in large part because he designed a sail that made it easier to steer ships, an invention that translated into greater sales. By 1832 James Forten was a very rich man. He was able to provide his family with a great many comforts money could buy.

James Forten also used his money to help others. He bought several people out of slavery. He made his home a way station for the Underground Railroad and became a major financial backer for William Lloyd Garrison's newspaper *The Liberator*. Among the other contributions he and his wife, Charlotte, made to the cause was their children. Their daughters Margaretta and Harriet (expert organizers and fund-raisers) and Sarah (a writer as well as an organizer) were so stalwart in their abolitionist work that John Greenleaf

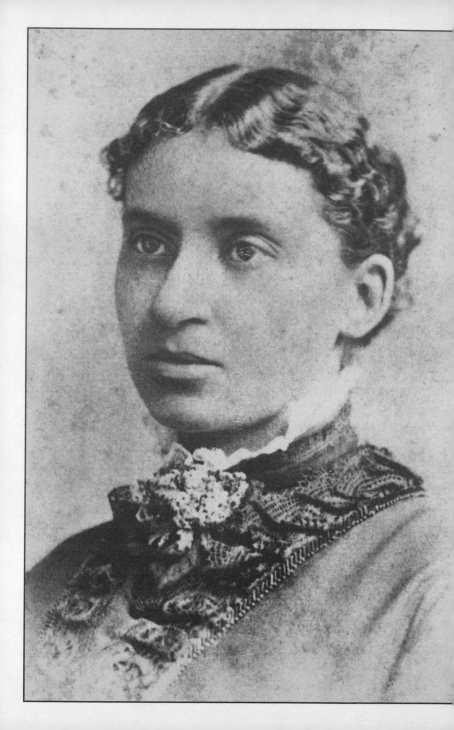

Whittier, the "poet laureate" of the antislavery movement, celebrated them in a poem: "To the Daughters of James Forten."

The Forten sisters carried out much of their work under the banner of the Philadelphia Female Anti-Slavery Society, of which, along with their mother, they had been founding members. Two of the Forten sisters married into an activist family: Harriet married Robert Purvis, and Sarah married his younger brother, Joseph.

Another founding member of the Philadelphia Female Anti-Slavery Society was Mary Woods, who married the Forten sisters' brother, Robert Bridges Forten. He, a mathematician, poet, and public speaker, was a member of the Philadelphia Young Men's Anti-Slavery Society. Mary and Robert Forten were Charlotte Forten Grimké's parents. And such was the type of family she was born into on August 17, 1837.

Sadly, Mary Forten, a very spirited, progressive woman, was unable to mold and shape her daughter, because she died when Charlotte was three. However, the child grew up in the good hands of her father, her grandmother, and her aunts Margaretta, Harriet, and Sarah.

Charlotte was forever trying to improve herself—intellectually, spiritually. As she once exclaimed in her diary, "Excelsior! shall be my motto, now and forever."

All her life she worked to move her mind "ever upward," and in the service of her race.

When Charlotte was born, the "City of Brotherly Love" had a long way to go in living up to its motto. In Philadelphia, free people of African descent were not only protesting slavery, but were also pressing for their own rights and protection of their lives and property. In 1838, when Charlotte was one year old, a mob burned down the newly built Pennsylvania Hall, where the Philadelphia Female Anti-Slavery Society held its meetings. Charlotte's Aunt Sarah had played a key role in the fund-raising drive for this hall. In that same year, another mob set fire to a black orphanage, vandalized one church, and burned down another, and a faction in the legislature ushered in a new constitution that took the vote away from free people of African descent. And soon, they were banned from private and public facilities, such as restaurants, theaters, and schools.

In her early years Charlotte was insulated from extreme degradation. She received her elementary education at home, from private tutors. For her secondary education, she was sent to a school in Salem, Massachusetts, which had a policy of integration, but where she was the only nonwhite student at the time.

And what a superb student she was. She loved learning, and it was something she would continue to do all

her life. "My studies are my truest friends!" she once wrote—she who would teach herself German and French and read, according to one source, roughly a hundred books a year.

Charlotte Forten continued her education in activism in Salem, too, for she lived in the home of her family's friend, the renowned antislavery lecturer Charles Lenox Remond. Living in the Remond home meant meeting a host of leading abolitionists, including William Lloyd Garrison, the Reverend Theodore Parker, Wendell Phillips, William Wells Brown, and Charles Remond's sister, Sarah Parker Remond, as impressive an antislavery lecturer as her brother.

Forten's associations and her nearness to Boston made it easy for her to keep up on some of the most dramatic moments in the antislavery movement. One was perhaps the most notorious enforcement of the Fugitive Slave Law. Sixteen-year-old Forten wrote of this 1854 incident in her journal:

*Thursday, May 25: Did not intend to write this evening, but have just heard of something that is worth recording. . . . Another fugitive from bondage has been arrested; a poor man, who for two short months has trod the soil and breathed the air of the "Old Bay State," was arrested like a criminal in the streets of her capital, and is now kept strictly guarded. . . .*

The man whose plight she lamented was Anthony Burns, a Baptist minister who had "stolen himself" from Colonel Charles Suttle of Alexandria, Virginia. Three of Boston's leading attorneys defended Burns. The next evening, Faneuil Hall was packed with protesters who had come to hear such speakers as the Reverend Theodore Parker. They listened, too, to the voice that cried out, "When we go from this Cradle of Liberty, let us go to the tomb of liberty—the courthouse!" The crowd met up with another group, led by the once enslaved Lewis Hayden and the Reverend Thomas Wentworth Higginson, who would later distinguish himself in the Civil War. The two streams of people set on freeing Burns found themselves outnumbered and outarmed by the military. They left to plot a rescue for another day.

Like most everyone else in the area, for days all Charlotte Forten could think about was the fate of Anthony Burns.

*Tuesday, May 30: . . . . I was very anxious to go [to the Anti-Slavery Convention in Boston], and will certainly do so to-morrow; the arrest of the alleged fugitive will give additional interest to the meetings, I should think. His trial is still going on and I can scarcely think of anything else. . . .*

*Thursday, June 1: . . . . The trial is over at last; the commissioner's decision will be given to-morrow. We are all in the greatest suspense; what will that decision be? . . .*

The next day would not be a bright day for the antislavery movement.

*Friday, June 2: Our worst fears are realized; the decision was against poor Burns, and he has been sent back to a bondage worse, a thousand times worse than death. Even an attempt at rescue was utterly impossible; the prisoner was completely surrounded by soldiers with bayonets fixed, a canon loaded, ready to be fired at the slightest sign.*

The return of Anthony Burns to Colonel Suttle—which one source estimates cost the government about forty thousand dollars—was for Charlotte Forten a "fresh incentive" to build up her mind and whole self so she would be fit to help change "the condition of my oppressed and suffering people." One of the ways she expressed her sympathies and anger was through poetry. Her first poem to be published was "To W.L.G. on Reading His 'Chosen Queen.' " It was a tribute to William Lloyd Garrison for his work toward the liberation of her people. It was her early attempt to be involved in such work herself. For her, this was not

merely a noble desire, but her Christian duty. These feelings she poured into her poems, only about a dozen of which were ever published.

Charlotte Forten did not develop into a great poet. Nor did she have the makeup or the constitution to be a mover and shaker like so many of her relatives and friends. In addition to being rather shy, she suffered from a respiratory ailment that left her confined to bed for long periods of time and would plague her all her life. So, she joined in the freedom struggle where she could, giving what she had, which early on was her verse. Her poetry was, then, her point of entry into social activism: it was through writing that she moved from being a sympathetic observer of the antislavery movement to a participant. Had she never taken this step, she might never have forged into the Port Royal Experiment, devoting almost two years of her life to teaching former slaves.

In November 1861, the Union army, under the command of S. F. Du Pont, battled and beat the Rebels at Port Royal Sound in South Carolina. With this victory they broke the stronghold the Confederate army had on the plantation-wealthy Sea Islands. In the wake of the Confederate defeat, the plantation owners fled, and their property was confiscated by the Union. This property included land and homes and everything

thereon and therein—including about ten thousand enslaved people.

Secretary of the Treasury Salmon P. Chase advised President Lincoln to use these liberated black people to prove that those so long regarded as things were fit for citizenship. The secret weapon in the experiment was education. The call went out in the North for teachers willing to journey to the South to ready men, women, and children for a productive freedom.

It was the poet and family friend John Greenleaf Whittier who told Charlotte Forten about this opportunity. She had taught off and on in Philadelphia, Salem, and Boston, and promptly applied to the Port Royal Commission in Boston. They rejected her application, supposedly because, as Forten wrote in her diary, "They were not sending women at present." Owing to Whittier's influence, however, the Philadelphia Port Royal Relief Association said yes to Charlotte Forten.

It all happened so quickly. She was notified of her commission on October 21, 1862. A few days later she was in New York aboard a steamer named *United States* setting out for Port Royal.

*At Sea. October 27, Monday: Let me see. Where am I? What do I want to write? I am in a state of utter bewilderment. . . .*

The next day she was settling in at her new home on St. Helena Island—"in the very heart of Rebeldom," as she put it. St. Helena, located midway between Charleston, South Carolina, and Savannah, Georgia, is one of the string of Sea Islands stretching up the Atlantic Coast from Florida to North Carolina. St. Helena was hot, wet, and mosquito-infested—and accessible to the mainland only by boat. The conditions under which Forten lived and worked were extremely trying, extremely exhausting. Everything was makeshift. But she persevered, putting up with the lack of comforts, the bugs, and classes with more students than she could easily handle. It was hardly an ideal situation for someone with poor health.

In addition to reading, writing, and arithmetic, Forten taught history, making a point of including in her lessons information about black history makers like Françoise-Dominique Toussaint-Louverture, the leader of the Haitian Revolution. And there was so much history she watched in the making!

Among her new friends was Thomas Wentworth Higginson, one of the would-be rescuers of Anthony Burns. Now a colonel, he was at St. Helena on a very special assignment: to command the First South Carolina Volunteers, an all-black regiment. Forten was supposed to join them as a teacher on their foray to

Florida, but Confederate victories in the area put an end to these plans.

Another young man whose path she crossed was Colonel Robert Gould Shaw, the white commander of the all-black Fifty-fourth Massachusetts Volunteer Regiment—the "Glory" corps. When she heard of Shaw's death in the Fifty-fourth's valiant charge at Fort Wagner, near Charleston, on July 18, 1863, she was quite distraught. She had been very fond of Colonel Shaw.

One of the most remarkable women Forten met was Harriet Tubman, the legendary conductor on the Underground Railroad, now serving as a spy, scout, and nurse for the Union Army. Forten first met Tubman during one of her trips to Beaufort for provisions.

*Saturday, January 31: . . . we spent nearly all our time at Harriet Tubman's otherwise [known as] "Moses." She is a wonderful woman—a real heroine. Has helped off a large number of slaves, after taking her own freedom. . . .*

Forten went on to record Tubman's recounting of one of her missions of liberation.

*My own eyes were full as I listened to her — the heroic woman! A reward of $10,000 was offered for her by the*

*Southerners, and her friends deemed it best that she sh'ld, for a time find refuge in [Canada]. And she did so, but only for a short time. She came back and was soon at the good brave work again. . . . I am glad I saw her—very glad.*

Forten's journal entries on her days of service in the Port Royal Experiment are a treasury of historical tidbits. They also offer a view of the small, everyday moments of life during the Civil War—the anxieties, sacrifices, and expectations of those living through it. Although Forten was never in the midst of any major battles, several times Confederate troops were dangerously near. She and her colleagues could have suffered injury or loss of life had they fallen into the hands of some "Johnny Rebs." Her journal, however, gives no indication that she suffered from any great fear. In fact, her Port Royal experience evidently brought up her level of courage. "I have never felt the least fear since I have been here," she wrote on March 2, 1863. "Though not particularly brave at home, it seems as if I *cannot* know fear *here.*"

In her journal Forten also left a record of one of her personal struggles: prejudice against her own people. Indeed, Harriet Tubman was among the few black people Forten had been "*very* glad" to meet. Though she was risking her life to teach these former slaves, she didn't really like them. Many in her family, like her,

were light-skinned, with hair closer in texture to a European's. The same was true of many of the black people she associated with in Philadelphia and Salem. Moreover, like most in her circle, she was educated according to European traditions and standards. In South Carolina, she was very much out of her element, dealing with unschooled people, the majority of whom were very dark-skinned, and most of whom had held onto many African cultural traditions. Forten constantly made references to people being "too black" or "so black." She made fun of their speech, their dress, their ways. Forten had almost no appreciation for Gullah, as black Sea Island culture has become known. The only thing about the Sea Islanders she thoroughly enjoyed was their singing.

Forten was a product of her times, and of her social class. As historian Brenda Stevenson explains in her introduction to *The Journals of Charlotte Forten Grimké*, just like the vast majority of the white Northerners who were braving all kinds of dangers to help former slaves, "Charlotte, who was an avid assimilationist . . . adamantly believed that blacks would never be accepted as equals to whites in society if they remained culturally distinct."

Despite her apparent snobbery and cultural confusion, Forten did great good on her tour of duty with the Port Royal Experiment. Her observations were

crafted into a two-part essay, "Life on the Sea Islands," which was published in the *Atlantic Monthly* in May and June 1864. These writings were an education to those who doubted that former slaves had a right to the tree of life. Her work was also part of the groundwork for what in later years would become St. Helena's Penn Normal, Industrial and Agricultural School. What Forten helped start exists today as Penn Center, a museum, historical site, and conference center, which is regarded as one of South Carolina's gems for its work in the preservation of Gullah culture.

Forten's assignment in South Carolina came to an end in May 1864, but it wasn't too long before she had another job: Secretary of the Teachers Committee of the New England branch of the Freedmen's Union Commission. Her task was to coordinate, recruit, and advise teachers working with freed people. Given her experience, she was surely an asset to the organization. However, she did not find this job totally fulfilling. Had her health permitted, she would have been out in the field, teaching again.

In time, Forten's health did permit this. In 1871 she returned to South Carolina to teach at the Robert Gould Shaw Memorial School in Charleston. After a year, she moved to Washington, D.C., to teach at the M Street School, a highly rated preparatory school later renamed the Paul Laurence Dunbar High School.

Forten remained at this school for two years and went on to take a job as a clerk with the United States Treasury Department. Out of a pool of five hundred applicants, she was one of the fifteen hired.

If a major measure of a person is his or her choice in a mate, then Charlotte Forten's marriage to Francis J. Grimké in 1878 reveals that she matured into a very serious woman, ever dedicated to the uplift of her race, and committed to her faith. It also reflects her disregard for traditional dos and don'ts in taking a husband, for she didn't marry until she was forty-one years old, something quite unusual in her day. Also, her husband was thirteen years younger than she, and he had not been born to the same social class as his wife had.

Francis J. Grimké and his brother Archibald were the sons of their owner, Henry Grimké, of South Carolina, and one of the women he kept in slavery, Nancy Weston. Years after they had made their way north, while they were both students at Lincoln University, in Pennsylvania, Francis and Archibald came to the attention of their father's sisters: Angelina Grimké Weld and Sarah Grimké, who had grown up to renounce their father's slaveholding and become Quaker abolitionists. The Grimké sisters not only embraced Francis and Archibald—acknowledging them as their nephews—they gave them money to continue their

education. Archibald graduated from Harvard Law School in 1874; Francis, from Princeton Theological Seminary in 1878.

Charlotte Forten and Francis Grimké met in Washington, D.C. Shortly after they married he became pastor of the Fifteenth Street Presbyterian Church. He went on to distinguish himself as a writer and scholar, all in the service of the attainment of equal rights and opportunity for his people. By all accounts, the Grimkés' thirty-six-year marriage was a happy one. They were kindred spirits, as passionate about racial equality as they were about art and literature and the life of the mind. From teaching Sunday school classes to organizing missionary work, Charlotte Forten Grimké worked tirelessly alongside her husband. She also continued to write, contributing poems and essays to various magazines. Some of her writings were purely creative and personal, while others were protest pieces in response to injustices. "The Problem of the Hour" and "One Phase of the Race Question" are among her essays that have survived. Forten also kept busy through her affiliations with various civic groups, most notably the National Association of Colored Women, formed in 1896, and of which she was a founding member.

Charlotte Forten Grimké's later years were by and large quite satisfying and productive. But there was one

long moment of deep and soaring grief in the Grimké home. Their daughter, Theodora Cornelia, born on New Year's Day 1880, died when she was a little over five months old. Recovering from such a tragedy was not easy, but the Grimkés did; and Charlotte found a "home" for her mother-love in her niece Angelina Weld Grimké.

Angelina was the daughter of Francis's brother Archibald. He had raised Angelina since she was seven, when her mother, a white woman, abandoned her marriage and her child under pressure from her own family. Angelina stayed with Aunt Charlotte and Uncle Francis for long periods of time, and they were her legal guardians when her father was serving as Consul of what is today the Dominican Republic. How pleased her aunt was when Angelina began to show a passion and promise for writing—poems, plays, short stories. And how proud she would have been had she known that in 1916 Angelina's play *Rachel* made history as the first play by an African-American woman to be published and professionally staged. Charlotte Forten Grimké died on July 22, 1914, following a stroke that had confined her to her bed for a little more than a year.

# Mary Fields

"She was a 6-foot, 200-pound, cigar-smoking, whiskey-drinking, gun-totin' pioneer who settled her arguments with her fists, and once in a while with a six gun."

This is how one chronicler quick-sketched the rambunctious Mary Fields, who made a little history in the Old West and in the process became known as "Stagecoach Mary."

Little is known about her beginnings, other than that she was born in the early 1830s, in Hickman County, Tennessee. Some have claimed that she was an escaped slave who made her way to Toledo, Ohio, following nothing but an impulse. Other sources maintain that she was once the property of a Judge Dunne, serving as his daughter Sarah's maid, and that after Emancipation she continued to work for Miss Dunne, who eventually became a nun. According to these accounts, Mary Fields ended up in Toledo because she followed Miss Dunne—later, Mother Superior

Amadeus—to the convent to which she had been assigned.

What is not disputed is that by 1884, when Fields was about fifty years old, she was living in Toledo, working as an all-around "handyman" at an Ursuline Convent. Ursulines are members of a Roman Catholic order founded in Italy in the sixteenth century for the purpose of educating girls. Another thing we know for sure is that Fields and the Mother Superior, two radically different women, had a bond that lasted forever—a bond that led to an adventurous life in the West for Mary Fields.

When in the early 1880s Mother Amadeus and four other nuns were sent on the mission field out West, she invited Fields to join them, but Fields chose to stay put. However, months later, when she heard that Mother Amadeus had gotten pneumonia during her westward journey and was close to death, Fields got moving. As tough as she was, it's not easy to believe that she journeyed the nearly two thousand miles alone, to the place some Native Americans called "the land of the shining mountains," and which European Americans eventually named Montana.

It was a vast place of dry-hot summers and fierce, far-below-zero winters; of great plains and mountains many miles high—most majestic of all, the Rockies. It was a place where the buffalo roamed, as did deer, elk,

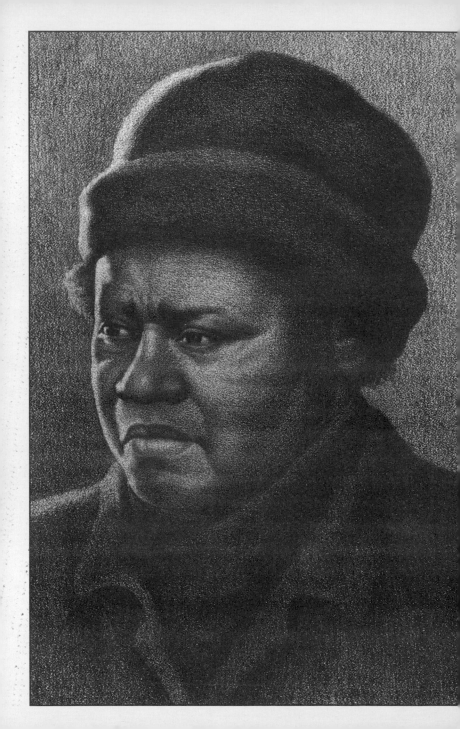

moose, and other creatures great and small. For many years this land had been home to Native American peoples—the Blackfeet, the Shoshone, the Arapaho, the Flathead. There were also the Sioux and the Cheyenne, whose warriors triumphed in the legendary Battle of the Little Big Horn in 1876, where General George Armstrong Custer had his last stand, his final defeat. The U.S. Cavalry eventually subdued the Native Americans, herding onto reservations almost all those they did not kill.

When Mary Fields arrived in Montana Territory in 1885, its population was mostly a mix of Europeans. They were descendants of the French, English, and Scottish adventurers who in the 1820s and 1830s had trapped animals and traded their furs. These Mountain Men, as they were called, had also opened up the Rocky Mountain region, making a way for what would become Oregon. Montana was home, too, to Irish, German, and Scandinavian folks who had come to work in the gold mines in the late 1860s, and to other European Americans who trailed up from Texas hoping to strike it rich as cattle ranchers.

As for African Americans, they were there, but not in great numbers. In his book *Black People Who Made the Old West*, William Loren Katz figured that when Mary Fields came to Montana, there were around 350 of her own kind in the territory's more than 140,000 square

miles of prairie. They were coal miners and cowboys. They were soldiers at Fort Shaw, Fort Assinibone, and Fort Missoula. They were homesteaders, too; and men and women pursuing various trades and businesses, like the innovative photographer J. P. Ball.

Montana was a lot of wilderness and a lot of wildness. It was a place most suitable for Mary Fields's temperament. In the beginning, her corner of this big-sky country was St. Peter's Mission, about fifteen miles northwest of the soon-to-be town of Dodge City, later renamed Cascade. This is where Mother Amadeus and the other nuns had been sent to start a school for Native American girls, along with other missionary work.

When Fields arrived at the mission, she was very glad and grateful that, though still ailing, Mother Amadeus was alive. After nursing her back to health, Fields decided to stay and work with the nuns. She cleaned, she did laundry, she gardened, and farmed. She also did nearly everything else that called for backbone and true grit: from light construction work on the convent building to driving a wagon to town and back laden with provisions and building supplies. Some say Fields picked up the work crew's bad habits like drinking and cursing (and some say she taught the work crew a thing or two), despite the efforts of the nuns to cultivate in her a meek and mild soul. "Mother

Amadeus tried to keep her from becoming rough and vulgar," wrote one resident of Cascade, "but Mary could not be managed."

Seeing as how Fields did so much "men's work," it was only fitting (though shocking to many) that she dressed mostly in men's clothing. Sometimes she wore a dress and apron over her pants; but one suspects that this wasn't an attempt to be more ladylike: Come winter, this getup, topped by a man's overcoat, would be a lifesaver, for many were the days and many were the nights that she braved bitter cold, and sometimes blizzards, in her journeys to and from Cascade.

The weather was not the only life threatener Mary Fields encountered. There were wolves along the way, too, a pack of which, with her rifle at the ready, she once stared down and staved off one long night after they spooked her horses into a frenzy that sent her wagon load tumbling. On another frightfully cold winter's night, when she did not return to the mission, she was given up for dead. The next day a search party was astounded to find Fields very much alive, and working to get her wagon back on track. How had she survived the subzero cold? "I just kept walking," she told the men. "I just walked up and down all night to keep from freezing."

Fields did not reserve her ferocity and fortitude for wild animals and wild weather only. She battled men,

too. On one occasion she got into a heated argument with the foreman of a nearby ranch. When he hit her with an insulting face and gestures, she hurled a large stone straight at his face. Another time, a verbal battle with one of the mission's hired hands escalated into a duel. Fields was the quicker draw. As the story goes: "She fired at the hired man, sending her bullets just close enough to let it be known she could make the shave closer if need be. The hired man took the hint and fled across the meadows."

Although this incident ended without bloodshed, it had grave consequences for Fields. For the Mother Superior's superior, Bishop Brondel, quartered about seventy-five miles away in Montana's capital, Helena, this was the last straw. True, he had received reports of Fields's enormous service to the mission, but he'd also heard about her drinking, swearing, and fights like this last one. He could tolerate no more of her cantankerous and combative ways, and charged Mother Amadeus to "Send that black woman away!" Mary Fields was bad for St. Peter's image.

When Fields heard about this she galloped to Helena to protest her banishment to the bishop's face. Although she did get a hearing, there is no record of what transpired between her and Bishop Brondel. What we do know is that this was one fight Fields lost.

Mother Amadeus had to obey her orders, but she did not send her faithful servant too far away.

During the ten years that Fields had worked at the mission, her paycheck had come in the form of room and board, tobacco, ammunition, and occasionally, a little cash. As far as we know, she never complained. In what could be considered back pay, Mother Amadeus helped Fields open what one of her contemporaries simply called an "eating house" in Cascade. But this restaurant didn't last too long. Not because Fields couldn't keep the customers coming back, but because this hard-as-nails woman had a soft spot for too many sheepherders and other seasonal workers who needed to eat now, but pay later. So while many a customer didn't go hungry, Fields did go broke. Twice. Both times, Mother Amadeus came to her rescue. Then, before Mary Fields could go broke a third time, Mother Amadeus helped her get a job.

It was steady work, hard work, and with one exception it had always been men's work. Mary Fields became a U.S. Mail carrier. Her route was between Cascade and the mission. Her first mode of transportation was a spring wagon with a team of four horses, supplied by Mother Amadeus. Her cargo was people as well as mail, heading to and from the mission, often with luggage, which Mary Fields had to

help carry when the wagon, and later her stagecoach, broke down.

When she started the job in 1895, she was over sixty years old; yet for the eight years that she worked this route, neither rain, nor sleet, nor dark of night stayed Mary Fields from her appointed rounds. In Cascade and its environs fantastic tales abounded about "Stagecoach Mary"—like this item that appeared in the *Cascade Courier* during this legend's lifetime.

> *Mary could drive. She could use a four-horse lash with a dexterity that made a man green with envy and she also could use a six-shooter with equal accuracy. There was a time when Mary's friends claimed if a fly lighted on the ear of one of the leaders of her four she could use her choice of either shooting it off or picking [it] off with her whip end and that if she was [of] a mind to, she could break the fly's hind le[g] with her whiplash and then shoot its eye out with [her] revolver.*

There were also accounts that on days of mountainous snowfalls, when it was impossible to travel the roads by horse, Mary Fields would fasten on her snowshoes, sling the mail sacks over her shoulder, and walk her fifteen-mile route.

In 1903, when she was over seventy years old, Mary

Fields stepped down from the stagecoach, and settled down in Cascade, where she went back into business: as a washerwoman. This enterprise, which she managed out of her two-room cabin, was more successful than her first, and it involved just as much, if not more, hard work. Doing laundry back then was a back-bending, hand-bruising chore. Clothes were scrubbed on a washboard in a tin tub or cauldron, with soap (probably lye), then lugged into another huge vessel for rinsing, then cranked through a wringer to squeeze out the excess water. Or maybe the only wringer she had was her hands. After the washing came the drying: hanging clothes outdoors on a clothesline (and if there was a storm of dust, or rain, or snow, a lot of work might go down the drain). Finally, there was the ironing: pressing down hard on a five- or six-pound cold iron that had been heated to a sizzle on a woodstove fire.

Mary Fields certainly had enough customers to keep her busy. By now, Cascade, which was born in 1888 during construction of the Montana Central Railroad, was becoming a hearty town with enough inhabitants to require schools and support a few churches and two hotels.

Just as old age had not hindered her ability to work, neither did it make Mary Fields simmer down her temper. If someone crossed her, she still did not hold her

tongue. Nor her hand. One person who found this out the hard way was a man who left town without paying his laundry bill of two dollars. When Fields encountered him two years later, she didn't bother asking him for the money, but simply grabbed him by the collar and punched him. To flabbergasted onlookers, she matter-of-factly explained: "His laundry bill is paid."

Mary Fields was not merely Cascade's leading laundress, she was a town treasure. When her house (and so, her business) burned down in 1912, scores of townsfolk chipped in money, time, and material to help her rebuild.

In addition to working as a laundress, Fields also did other odd jobs in her twilight years, including something many might think out of character: baby-sitting. This rough-and-tumble woman had a great fondness for and a tender way with children. One of her customers was D. W. Munroe, the second mayor of Cascade, whose four sons Fields often took care of. As she did with the other children she kept, she treated the Munroe boys to candy and other goodies with the very money she earned from baby-sitting.

Fields's complexity—one moment tough, the next, quite sweet—is also revealed in the fact that by all accounts her pride and joy was her flower garden; and she often shared its bounty of her favorite flower, the

pansy, and other posies with her neighbors. Cascade's baseball team was the primary recipient of Fields's flowers. She was not merely crazy about baseball; she was the team's mascot. As its good luck charm, she didn't dress up in a clownish outfit, but for every game she did make buttonhole bouquets for each man on the team, plus a handful of large bouquets to go to home run hitters.

Some of what we know about Mary Fields comes from one of Montana's favorite sons: Gary Cooper, a one-time cowboy turned two-time Academy Award-winning actor who starred in a number of Western movies. Cooper's hometown was Helena, but he had family in Cascade. It was during visits with these relatives that he caught glimpses and gathered news of Mary Fields. He remembered her quite vividly in an article that appeared in *Ebony* magazine in 1959.

*I remember seeing her in Cascade when I was just a little shaver of nine or so. She smoked cigars until the day she died in 1914. She must have been about 81 as near as anyone could figure. She celebrated two birthdays a year because she didn't know the exact date of her birth, but they would close Cascade schools in her honor whenever she felt like having one.*

*They say Mary had a fondness for hard liquor that*

*was matched only by her capacity to put it away and it's*
*[a] historical fact that one of Cascade's early mayors,*
*D. W. M[u]nroe gave special permission to let Mary drink*
*in the saloons with men, a privilege, if you want to call it*
*one, given to no other woman.*

To be sure, Mary Fields was no ordinary woman. Cooper summed her up well when he called her "one of the free[e]st souls ever to draw a breath or a .38." And she had wanted to die as she had lived—independently.

She fell ill (of what we do not know) in the fall of 1914. She tried to continue to work, but she was eventually forced to "take to the sick-bed." Then came the day when Mary Fields knew she was dying. Instead of calling for folks to gather around her deathbed, she slipped from her cabin, blankets in hand, and made her bed in a field overrun by tall weeds. She wanted no one fussing and fretting over her. She wanted no pity. She wanted to die alone, out under the big sky.

The Munroe boys were the ones who found her, close to death. Against her will, Mary Fields was taken to the hospital, where she died on December 5, 1914. She was buried in Hillside Cemetery, "at the foot of the mountains, by the winding road that leads to the old mission."

A notice headlined "Old Timer Passes Away," which appeared in the *Cascade Courier* a week after Mary Fields died, tells us that her death more than mattered to the people of Cascade.

*The funeral services of Mary Fields were held in the Pastime Theatre Tuesday afternoon at 3:15. . . . There was a large attendance of friends and acquaintances of the deceased, many of them having known her for over twenty-five years, who left nothing undone to make the services complete in every respect for one of the oldest land marks in Cascade. The floral contributors were especially in evidence.*

In his remembrance of Mary Fields, Gary Cooper noted that she had been remembered by the famous cowboy artist and one-time resident of Cascade, Charles M. Russell, in a pen-and-ink drawing that eventually ended up in the care of the Montana Historical Society. This sketch, created in 1897, depicts a passel of action-packed incidents in the town's history. Almost dead center is Mary Fields—not kicking up a ruckus, but with her rump on the ground, along with a bag of groceries and a basket of eggs. She had been sideswiped by a runaway hog. Russell titled this piece "A Quiet Day in Cascade."

Mary Fields lived loud; she lived large. She had

some bad habits and some very ugly ways, but she also had a good heart. Most of all she had nerve, spunk, and spirit, which is what it took to survive in the Old West days, especially if you were without any kin or many of your own kind around.

# Ida B. Wells

$\mathcal{I}$da Bell Wells was born on July 16, 1862, a little over a year after the start of the Civil War. Although Holly Springs, Mississippi, served as Union Army headquarters for a time—until Confederate forces routed the Yankees—no bloody battles savaged her little town.

The yearning for freedom raged strong within her mother, Elizabeth, a cook, and her father, James, the son of his master and a carpenter by trade. When freedom came in 1865, they embraced it with all their might and began readying their little girl for a brighter life. Very soon after the war, the federal Freedmen's Bureau started a school in Holly Springs, which years later evolved into Rust College. Ida's father became a trustee of this new school, which his children would attend.

The value of education was not the only thing Ida learned from her father. He also was a model for race pride, and standing your ground. For example, in

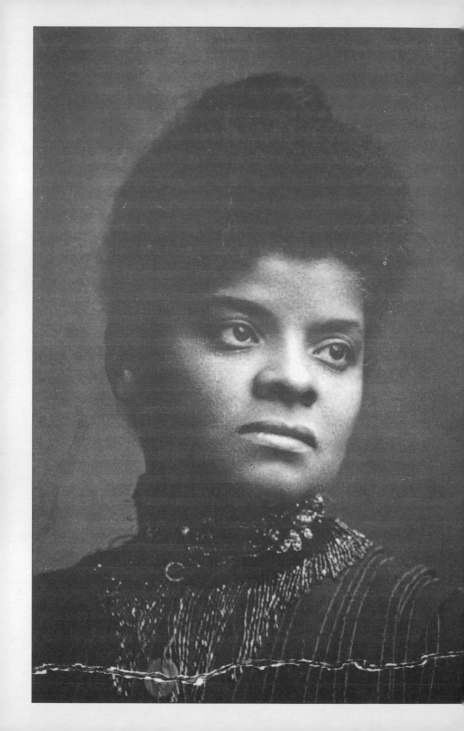

1867, Mr. Wells announced his intention to exercise his newly granted, highly priced right to vote in the Mississippi elections. His employer, who was also his landlord, urged him to vote *his* way—against the Republicans. But like ninety-nine percent of his people, Ida's father believed in the party of Abraham Lincoln—and he paid a price for his convictions, for when he returned from the polls, he found that his boss had locked him out of the shop, locking in the tools of his trade that belonged to him. Mr. Wells was not about to beg for forgiveness, or his tools. He set up house—and a carpentry shop—across the street.

Standing up to this white man was an especially courageous act, considering that many African Americans had been treated to violence for less. Like others in Holly Springs and the surrounding area, Ida's parents were still wincing from the memory of what a white mob had done to the African-American community in Memphis, Tennessee, the previous year. After the mob's three-day, lawless spree, there were about fifty African Americans dead, about eighty wounded, and four churches, a dozen schools, and more than fourscore houses in ashes. Ida was about four at the time, not too young to know the dangers that African Americans faced. "I heard the words Ku Klux Klan, long before I knew what they meant," she wrote years later, adding that she knew the words "meant something

fearful" from the way her mother paced the floor on nights when her father was at political meetings.

During her childhood Ida also knew plenty of hard work. As the oldest, she was her mother's primary helper with housework and the care of the younger children. This training came in handy sooner than she had expected. When Ida was sixteen, a yellow fever epidemic made orphans of the Wells children.

Ida was visiting her grandmother, who lived about thirty miles away in Tippah County, when yellow fever struck Memphis, Tennessee, and then burned its way south, ravaging Holly Springs. Among the many victims it left in its wake were Ida's parents and her nine-month-old brother.

When Holly Springs was still a danger zone, against the advice of her elders, Ida took a freight train home, worried sick about her brothers James, Jr. (age eleven) and George (age nine), and her sisters Eugenia (age fifteen), who two years before had been stricken with a disease that left her paralyzed from the waist down, Annie (age five), and Lily (age two). What would become of them, and of her? Ida fretted.

Mr. Wells had been a Mason, a secret social and civic men's organization. His lodge brothers were duty-bound to look out for his children. In fulfilling this obligation, they proposed to apprentice James and George as carpenters and send Annie and Lily to

families where a little girl—but only one—was desperately wanted. As for Ida, the men reasoned that since she would soon be a woman, she was old enough to take care of herself. Because of her handicap, Eugenia was a burden no one wanted to bear. She would be sent to the poorhouse.

When the men sentenced the Wells children to separation, Ida was speechless with grief and anger. But soon she found her voice. "I said that it would make my father and mother turn over in their graves to know their children had been scattered like that," she recalled years later. Ida then presented the Masons with a counterproposal: If they would help her find a job, she would take care of her siblings. When she refused to budge from her position, they suggested that she try for a job as a teacher.

Ida B. Wells passed the teacher's examination and was appointed to a one-room schoolhouse in the country, with a salary of twenty-five dollars a month. Thus, she became head of a household, with five younger brothers and sisters to support. But she had help. Her parents had left a nest egg of a few hundred dollars, and there was her grandmother and a friend of her mother's to help with the children. These women were blessings, indeed, because Wells stayed out in the country from Monday to Friday, boarding with her students' families. And so it went week after week,

month after month, until Wells moved to Memphis, Tennessee, taking Annie and Lily with her, while poor, helpless Eugenia went to live with Aunt Belle, their mother's sister. As for James and George, they went to work but later moved to Memphis, too.

Ida B. Wells eventually found a teaching job on the outskirts of Memphis. She was grateful for the work, but admitted that she "never cared for teaching." Yet, she gave it her all because she was determined to be independent, and teaching was one of the few respectable careers open to African-American women then.

For Wells, Memphis was a far better place to be. As Miriam DeCosta-Willis points out in her introduction to *The Memphis Diary of Ida B. Wells*, this country girl took a big fancy to this bustling city: "She was excited by the glitter: the gaslit theaters, cobblestone streets, railroad terminals, department stores, churches and synagogues, schools and hospitals, and the waterfront, teeming with steamboats and cotton barges."

With her move to Memphis in the early 1880s, Wells began to blossom. She loved reading, going to the theater, and receiving quite a few "gentlemen callers." She was a member of a lyceum, a group of young men and women who met on Fridays for readings, recitations, and musical programs. Wells also became editor of a literary newsletter, the *Evening Star*.

Through her activities, she made the acquaintance of many prominent members of the city's African-American community, such as millionaire-businessman Robert R. Church and his daughter Mollie, who grew up to be the formidable civil and women's rights activist Mary Church Terrell.

Another of Wells's pastimes was corresponding with old friends and new acquaintances, sometimes writing as many as ten letters a day. Given the limitations on travel and the fact that Alexander Graham Bell had only patented the telephone in 1876, letters were really the only way to keep in touch and develop relationships. They were also a place for shaping and expressing her ideas, for having intelligent conversation. Unbeknownst to her, all this letter writing, plus her work on the *Evening Star*, was preparation for a career in journalism.

It was an unfortunate incident that catapulted her into this career, a humiliation that gave her something to really write about.

One day in early May 1884, Wells, now in her twenties, boarded a train in Memphis. Since she had purchased a first-class ticket, she took her seat in a first-class car. However, the conductor refused her ticket and ordered her to move to another car: the filthy smoking car, which the officials of the Chesapeake & Ohio Railroad had decided was "good enough

for the colored." Some thirty years before Rosa Parks was even born, Wells took a stand, sitting down: She refused to budge. When the conductor attempted to move her, she bit his hand. But her victory was short-lived. He called for backup. All four feet six inches of Wells was soon pulled out of her seat and out of the car, with white passengers applauding the men.

What happened to Wells was a sign of the times.

The year before, the United States Supreme Court had ruled as unconstitutional the Civil Rights Act of 1875, which declared that African Americans were to be treated as first-class citizens in restaurants, theaters, hotel, trains, and such. There was now no national law against discrimination. States were free to do as they pleased on the issue of civil rights. In 1884, Tennessee, like many Southern states, was putting in motion laws that would allow segregation in public places and no-blacks-allowed policies in the private sector. It was the dawn of Jim Crow.

Rather than accept the humiliation of being forced to sit in the second-class coach, Wells got off the train.

She was beyond furious. As she would admit later in life, her temper was her "besetting sin." Fortunately, she almost always found a constructive outlet for her anger. In this case, she sued the railroad. Ida B. Wells won, and the railroad was ordered to pay her five hundred dollars.

The ruling was not merely a personal gain for Wells, but also an important victory for the civil rights movement underway since the end of the Civil War. The city's white-owned paper, the *Memphis Daily Appeal*, scoffed at what was such good news for Wells and her people at large. The headline to the story of the verdict, which appeared on Christmas Day 1884, began: "A Darky Damsel Obtains a Verdict for Damages Against the Chesapeake & Ohio Railroad."

Again, Wells's victory was short-lived. The railroad appealed the case, and on April 4, 1887, the Tennessee Supreme Court overruled the verdict, maintaining that the smoking car qualified as first-class accommodation "for the colored." Wells was shocked, and deeply pained. A week after the ruling, she wrote in her diary:

> *I felt so disappointed, because I had hoped for such great things from my suit for my people generally. I have firmly believed all along that the law was on our side and would, when we appealed to it, give us justice. . . . O God is there no redress, no peace, no justice in this land for us?*

Wells wrote about her suit against the railroad for the *Living Way*, a Baptist weekly. The editor was so impressed with the content and character of her piece that he invited her to write a regular column. She would write about a range of social and political

issues and she would choose as a pen name "Iola."

"Iola" became quite a sensation. Her "letters," as these essays were called, began appearing in many major African-American-owned newspapers and magazines: the *New York Age*, the *Detroit Plaindealer*, the *Indianapolis Freeman*, the *American Baptist* of Louisville, Kentucky, and Philadelphia's *A.M.E. Church Review.* Soon she was hailed as the "Princess of the Press." Some male journalists were rather condescending; but others gave Wells her due. For instance, T. Thomas Fortune, founder of the *New York Age*, once noted that Iola "handle[s] a goose quill with diamond point as easily as any man in newspaper work" and "has plenty of nerve and is as sharp as a steel trap." Among the biting pieces Wells penned were "Functions of Leadership," "Woman and Leadership," and "Iola on Discrimination."

For Wells, writing was a way to educate, motivate, and empower others. It was also a labor of love. In the beginning, payment came in the form of free subscriptions and extra copies of the periodicals for which she wrote. Her first paying assignment was with the *American Baptist* for "the lavish sum of one dollar a letter weekly!" She wasn't being sarcastic: She could buy a pair of shoes for about two dollars and a half. Still, she wasn't earning enough from her freelance writing to leave teaching. But she wished she could. As she put it:

"Since the appetite grows for what it feeds on, the desire came to own a paper."

This desire was satisfied when the Reverend Taylor Nightingale (sales manager) and J. L. Fleming (business manager) asked her to be the editor of their newspaper, the *Free Speech and Headlight*. Wells accepted the job, but only after Fleming and Nightingale agreed to let her buy a one-third interest in the business and become a co-owner of what was soon renamed the *Free Speech*.

Wells's pen points became even sharper. A piece about the immoral conduct of a minister lost her a few friends. Another, about the school board's neglect of schools for African Americans, got her fired from her teaching job. Now that it was her only source of income, Wells *had* to make the *Free Speech* a more profitable business. To this end, she went on a lengthy tour of Tennessee, Arkansas, and Mississippi, canvasing for subscriptions and advertising. Through her efforts the *Free Speech*'s circulation rose from fifteen hundred to four thousand, and she had very high hopes for more readers. Then, something happened in a section of Memphis known as the Curve, which Wells said changed the whole course of her life.

In early March 1892, while Wells was in Natchez, Mississippi, promoting the *Free Speech*, another newspaper delivered her some dreadful news. Her friend

Thomas Moss, co-owner of the People's Grocery Company, and his partners, Calvin McDowell and Henry Stewart, had been lynched. The men had defended themselves against an armed gang, incited by a white grocer across the street, who resented the People's Grocery because it meant fewer black dollars were coming his way. This man thought he might scare Moss, McDowell, and Stewart into going out of business. He had not expected them to defend their persons, their property, and their right to engage in free enterprise. He had not expected things to escalate into a full-fledged fight, but it did, and three of the white thugs were shot. Moss, McDowell, and Stewart were summarily thrown in jail on that terrible Saturday night.

In no time at all, a mob formed outside the jail. Knowing what such a mob was capable of, a group of African-American men also gathered at the jail. They had been disarmed by a court order, but they were there, anyway, hoping that their presence would be a deterrent to violence. When word came that the white men's wounds were not fatal, the African-American men thought the danger was over. They left, and the African-American community breathed easier. But the men had all been too optimistic.

Around daybreak, a mob broke into the jail, snatched Moss, McDowell, and Stewart out, and took

them to the outskirts of town, where they faced a hail of bullets and their dead and dying bodies were hanged.

No African American in Memphis was able to rest easy that day. When a group gathered at the People's Grocery to talk about and mourn the lynching, a judge ordered the sheriff to "take a hundred men, go out to the Curve at once, and shoot down on sight any Negro who appears to be making trouble." A group of white Memphians followed the judge's directive and went "hunting." In the process, they looted the People's Grocery, destroying what they did not eat or cart away.

Generally, the word "lynch" brings to mind an image of a person hanging from a tree. But lynching is not the act of hanging. It is mob-murder, be it by burning, by beating, or by shooting. Usually lynching is a spontaneous act; but often lynchings have been planned—and even announced ahead of time, so that people could come and watch. Though not all those lynched in this nation have been African Americans, the overwhelming majority have been. For example, according to Carter G. Woodson ("the Father of Black History"), from 1885 to 1918 there were 3,224 lynchings, and 702 of the victims were white.

Ida B. Wells mourned for all three men lynched that early March morning in Memphis, but doubly so for

Moss, her friend. He had been an upstanding member of the community, who worked by day as a postman, the first African American in the city to do so. She was pained for his widow, Betty Moss, also a good friend, for the couple's little girl and boy, to whom Wells was godmother, and for the as yet unborn child Mrs. Moss was carrying at the time. Wells was grieved in a new, more profound way for her people as a whole.

It had been reported that Thomas Moss's last words were: "Tell my people to go West—there is not justice for them here." Wells pressed for some justice in her editorials in the *Free Speech*. But the murderers, whose identities were no secret, were never even arrested.

Abandoning all hope for justice, Wells championed Moss's cause and wrote editorials exhorting the African-American community in Memphis to heed his parting words. Wells wrote:

> *The city of Memphis has demonstrated that neither character nor standing avails the Negro if he dares to protect himself against the white man or become his rival. There is nothing we can do about the lynching now, as we are out-numbered and without arms. . . . There is therefore only one thing left that we can do; save our money and leave a town which will neither protect our lives and property, nor give us a fair trial in the courts, but takes us out and murders us in cold blood when accused by white persons.*

Many did as Moss and Wells urged, heading for Kansas and for Oklahoma Territory. So many left that the white community soon became alarmed, and then enraged. This black exodus meant fewer customers for white merchants, more vacancies for white realtors and landlords, and fewer workers for businesses. And many middle- and upper-class white women would have to clean their own houses now that the pool of domestics was getting smaller. White Memphis began to see black Memphis in a whole new light: as a valuable resource.

Ida B. Wells came to see lynching in a whole new light and she turned her journalistic attention to the problem, researching some seven hundred cases of white-on-black mob-murder, and finding that most who had been lynched had not even been guilty as charged by the vigilantes.

Not only did Wells discover that time and again the popular charge of rape of a white woman was very often bogus, she also found that many African-American men had been lynched for arguing with or talking back to a white person, for petty theft, and for just "being black." She found, too, that the lynch victims included women and teenagers.

In *100 Years of Lynchings*, first published a century after Wells was born, in 1962, Ralph Ginzburg collected hundreds of newspaper accounts that bear witness to

the "red record of racial atrocities" in the United States. This book provides examples of the kinds of incidents Wells investigated and the kinds she tried to prevent. The first entry is an item from the *New York Truth Seeker*, dated April 17, 1870, and headlined "Negro at West Point Knifed by Fellow Cadets."

> *WEST POINT, N.Y., Apr. 15—[A] colored cadet was recently taken from his bed, gagged, bound, and severely beaten, and then his ears were slit. He says that he cannot identify his assailants. The other cadets claim that he did it himself.*

It was incidents like this that led Wells to the conclusion that lynching was about more than some kind of abstract hatred. It was ultimately a way, as Wells explained, "to keep the race terrorized" so as to keep her people from progressing socially and economically.

Knowing that she would incur the wrath of some white people, Wells spoke out boldly about lynching in the *Free Speech*. One of her editorials so incensed some that a white-owned newspaper, the *Commercial Appeal*, reprinted it with the statement that "the black wretch" who had written the piece ought to be "tied to a stake" at the corner of two of the city's main streets and, after getting done up with a pair of tailor's scissors, burned. After more riot-inciting words, the newspaper

closed with, "We hoped we have said enough."

They had. That evening a committee of "concerned citizens" broke into the *Free Speech* and tore it apart. They left a parting note promising death to Ida B. Wells.

When Wells received the threat, she was hundreds of miles away. Right after she had finished her editorial, she'd left Memphis to attend an African Methodist Episcopal Church conference in Philadelphia. While East, she had gone to New York City to visit fellow journalist T. Thomas Fortune and other friends.

Given her temper, it is not surprising that Wells's first impulse was to return home immediately. But she was not a fool. She knew that the committee was quite capable of making good its threat. She knew, too, that she could do more for her people alive than dead. So she remained in New York, becoming an even greater force in exile. Her base was T. Thomas Fortune's *New York Age*, through which she stepped up her antilynching crusade.

Her first major show of support came from a group of African-American women. Author and staff writer for the *New York Age*, Victoria Earle Matthews was one of the organizers of a testimonial dinner for Wells. The event, held on October 5, 1892, at New York City's Lyric Hall, was attended by leading civic-minded women in the East. This dinner was not only a great

inspiration for Wells, it was also an historic moment for African-American women, for it was the spark of the Negro women's club movement, fostered by a host of political and social service organizations that sprang up in the late nineteenth and early twentieth century.

At Lyric Hall, the courageous "Iola" was given five hundred dollars to help her resurrect the *Free Speech*. But Wells did not restart the newspaper. Instead, she used the money to publish a pamphlet, *Southern Horrors: Lynch Law in All Its Phases.* Armed with this publication and her righteous indignation, she began lecturing around the country to raise awareness about lynching and to induce others to form antilynching societies that would recruit supporters and pressure the government to do something about this injustice.

Wells took her campaign across the Atlantic. In 1893 and again in 1894, she broadcast her country's "red record" through the written and spoken word in England, Scotland, and Wales. She was hopeful that the energies and resources the British had put into the antislavery movement would be channeled into the antilynching crusade. The formation of the London Anti-Lynching Committee, headed by Queen Victoria's son-in-law, was just one example of how England responded to the challenge. Wells's appeal to the British infuriated many white Americans. They told the British, in so many words, to mind their own business.

They also made sure that articles attacking Wells's character reached England.

Soon after her return to the United States in 1894, Wells settled in Chicago where a year earlier she had formed the Ida B. Wells Club. On both sides of the Atlantic, Wells was most effective. Whenever she traveled, she left in her wake more concerned citizens and antilynching organizations. Along the way she produced another document to bolster her efforts: *A Red Record: Tabulated Statistics and Alleged Causes of Lynchings in the United States, 1892, 1893, 1894,* published in 1895. This small book opens with one of Wells's most widely known pieces of writing, "The Case Stated," where she clearly and concisely speaks about the root causes of lynchings and informs the reader that of the thousands of African Americans lynched since the end of the Civil War, "only three white men have been tried, convicted, and executed."

Wells's antilynching campaign had a profound impact on African-American life and the consciences of many whites. Lynching could no longer be ignored and more and more it was openly condemned.

In 1897 Wells retired from public life. A few years earlier she had married a widower with two sons, Ferdinand L. Barnett, an attorney and publisher of Chicago's first African-American weekly, the *Conservator,* of which Wells eventually became editor.

Ferdinand Barnett was a very supportive husband, who aided his wife in her work, both through his newspaper and with his legal skills. He never tried to curb his wife's activities, and would take care of their baby, Charles (born 1896), and the older boys on those occasions when she did not take the child with her on the road. But with the birth of her second child, Herman, in 1897, Wells decided to be a full-time mother.

When Herman was five months old, however, Wells was pressed back into public service. A newly appointed postmaster in Anderson, South Carolina, was murdered by a mob in a particularly vicious way. Wells's supporters in Chicago raised money to send her to Washington, D.C., where she met with President William McKinley and urged him to make lynching a federal crime. McKinley expressed concern, but he had another matter on this mind. Soon after Wells arrived in the capital, Congress declared war on Spain in 1898. With the Spanish-American War to deal with, McKinley would not make lynching a national priority, even if he had truly wanted to.

Lynching, along with other impediments to African-American life and liberty, would always be a priority for Wells, even though it put her own life in jeopardy and earned her extremely nasty attacks from

many in the white press. This hostility was enraging and hurtful, but it was not as painful as the resistance and lack of help from people she naturally assumed would be ardent supporters.

While many white ministers did support her movement, too many failed to preach against lynching (and racism in general) in their pulpits. For her, their silence gave consent. Wells felt the same about Frances E. Willard, president of the Women's Christian Temperance Union, the major women's organization of the time. Willard did not condemn lynching and she publicly perpetuated images of African Americans as menaces to society. Wells's criticism of Willard upset many important white women, including suffragist Susan B. Anthony, who tried to persuade Wells to hold her tongue about Willard. It saddened Wells to discover that Anthony was not the friend to African Americans she had once thought her to be.

Many African-American male leaders also failed to support Wells's work, not because it was wrong but because she was a woman. Like the majority of men of that day, while they may have applauded a woman's contributions to a cause, they felt that it was inappropriate for a woman to be too out front and center. Moreover, there were those who felt that Wells was simply "too radical." Chief among them was Booker T.

Washington, cofounder of Alabama's Tuskegee Institute and the most politically powerful African American of the day.

Wells criticized Washington for not speaking up and *out loud* about lynching. For his part, Washington felt that the activism of people like Wells (and later W.E.B. Du Bois) on this and other issues was counterproductive, that open protest was a bad thing. Washington branded Wells a troublemaker, and on more than one occasion he hurt her campaign. Many African Americans who headed educational and social institutions decided not to openly support Wells because they were afraid of Washington. He had influence with powerful white people, including Presidents William McKinley and Theodore Roosevelt. Such people generally took his advice on which African-American issues and organizations to support and which to ignore.

It was her criticism of Washington that led the National Association of Colored Women (NACW) to distance itself from Wells. Although Wells had helped found the organization, Booker T. Washington's wife, the very powerful Margaret Murray Washington, was a member. The NACW's rejection was especially hurtful because it was supported by its president, Mary Church Terrell, whom Wells had known since they were young women in Memphis.

Undaunted, Wells pressed on in her sometimes lonely crusade—through her writings, speeches, and work as director of the Anti-Lynching Bureau of T. Thomas Fortune's Afro-American Council. She continued to keep record of and investigate incidents like these:

### SAM HOLT BURNED AT STAKE
( Kissimmee Valley *(Florida)* Gazette,
*April 28, 1899)*

*Sam Holt, the negro who is thought to have murdered Alfred Cranford and assailed Cranford's wife, was burned at the stake one mile and a quarter from Newnan, Ga., Sunday afternoon, July 23rd, at 2:30 o'clock. . . .*

*For sickening sights, harrowing details and blood-curdling incidents, the burning of Holt is unsurpassed by any occurrence of a like kind ever heard of in the history of Georgia. . . .*

*One of the strangest features of the entire affair is the part played in the execution by a northern man. This man, whose name would not be divulged by those who knew him, announced that he was from the north, while he calmly saturated Holt's clothing with kerosene oil. . . .*

*Mrs. Cranford, the rape victim, was not permitted to identify the negro. She is ill and it was thought the shock*

*would be too great for her. The crowd was satisfied with the identification of Holt by Mrs. Cranford's mother who did not, however, actually see Holt commit the crime.*

*Masks played no part of the lynching. There was no secrecy. . . .*

### NEGRO FREED, THEN LYNCHED
(Chicago Record, *January 4, 1901*)

*ROME, Ga., Jan. 3—George Reed, a negro charged with attempting to assault Mrs. J. M. Locklear of this city last night, was hanged to-day to a tree. His body was then riddled with bullets by a mob of 150 men. Reed protested his innocence.*

*After his arrest this morning the negro was taken before Mrs. Locklear, but she failed to identify him and he was returned to jail. However, the mob . . . was not satisfied. . . .*

The number of lynchings reported in 1903 was 104, and for the next year, 87. By now, Wells was in her forties and had given birth to two more children, Ida and Alfreda. Age and a growing family restricted her activism, but it did not make her quit. How could she, when newspapers continued to carry reports like this one from the March 18, 1906, edition of the *New York Tribune,* headlined: "Is Lynched by 'Orderly' Mob; Suspected of Cow Killing."

*PLANQUEMINES, La., March 17—William Carr, Negro, was lynched without ceremony here today by an orderly party of thirty masked men who hurried him to a railroad trestle and hanged him. He had been accused of killing a white man's cow.*

As part of her antilynching crusade, Wells continued to involve herself in issues and organizations relevant to equal opportunity and justice for African Americans. She was a founding member of the National Association for the Advancement of Colored People (NAACP), which was formed in 1909. In 1910 she started the Negro Fellowship League, a settlement house in Chicago for Southern male migrants, which she and her husband funded. In 1913 she started the Alpha Suffrage Club, to increase the political awareness of African-American women in Illinois, who had just received the right to vote.

The number of lynchings continued to decrease. Increasing numbers of white people were finding lynching unacceptable. Many objected solely on moral grounds. For others, it was purely a matter of economics. Around 1910 a sizable number of African Americans began migrating north, in search of better jobs and to escape terrorism. This migration would not become "great" until after World War I, but it had enough of an effect on white life to inspire editorials

such as this one in the August 15, 1913, edition of Memphis's *Commercial-Appeal*, which declared: "Lynching Bad for Business."

> [K]illing Negroes just because one is in a bad humor ought also to be stopped. . . .
>
> Now, the Negro is about the only dependable tiller of the soil in these parts. Competition for existence is not keen enough to force many white people into the harder work.
>
> The Negro also is very useful as a distributor of money. About all he gets goes through his fingers.
>
> Commercially, then, he is a very valuable asset. It is not good business to kill them. . . .

The number of reported lynchings for 1913 was forty-eight, and the annual count continued to go down. Wells remained vigilant, however. She investigated the spate of antiblack riots that swept the nation right before the end of World War I, in which hundreds of people were maimed, killed, or driven out of a town. As always, Wells made her findings known. One of the worst riots she investigated was the one that occurred in East St. Louis in July 1917. Then, in the summer of 1919, the riots in Chicago and other cities were so bloody that the period became known as the "Red Summer."

The movement to end these atrocities was strengthened when, in 1919, the NAACP held a national conference on lynching and raised funds to investigate the horrors and to campaign for an antilynching law. The NAACP gained support through articles in its magazine, *The Crisis*, whose editor was NAACP cofounder W.E.B. Du Bois, and through booklets such as *Thirty Years of Lynching in the United States, 1889–1918* and *Burning at Stake in the US* (1919). The NAACP attracted a variety of social and civic organizations to join in the antilynching crusade.

Wells had laid the foundation for all this. Now others championed her cause as strongly as she had for the past three decades. Still, she did not cease her activism. In 1930, when Wells was in her sixties, she ran for the senate, reasoning that she might be a greater crusader for justice in her state by working within the system. She lost.

But Wells was not defeated until March 25, 1931, when she died of a kidney disease. She collapsed four days earlier at home, while at work on her life story. She was close to the finish when the kidney attack literally cut her off in midsentence. This book was eventually edited by her daughter Alfreda Duster and published in 1970 with the title *Crusade for Justice: The Autobiography of Ida B. Wells*. In his review of the book, a

writer for the *New York Times*, Walter Goodman, remarked that Wells was "a sophisticated fighter whose prose was as tough as her intellect." Historian John Hope Franklin said of the book: "Few documents written by an American woman approach this one either in importance or interest." This would come as no surprise to those who knew that our nation has seen few people as intrepid as Ida B. Wells.

# Mary McLeod Bethune

Before Mary McLeod Bethune became impressive and extraordinary, she was just a little "colored" girl in a town near Mayesville, South Carolina, so small that it never even became a dot on the map.

She was born on July 10, 1875, to parents who had both been slaves, Patsy and Samuel. As for their last names, these they shared with who knows how many others owned by two prosperous landowners of Scottish descent. Patsy was raised on the McIntosh farm, near Mayesville; Samuel, on the McLeod plantation, not far away. When Patsy and Samuel fell in love they were allowed to seal their love with marriage, but there was a price. Samuel would have to buy his beloved. He managed to do this by working the fields of nearby planters and farmers in between and around his labors for his owner. It took time, but eventually Patsy and Samuel became husband and wife.

After Emancipation, Patsy and Samuel found a way to purchase some farmland between Mayesville and the

town of Sumter, and on it the family built a log cabin. The Homestead was what they named their place. They fished from its streams; they hunted small feathered and furry game from its woods. They supplemented their meals with vegetables and fruits from their garden. On the rest of the land they raised their cash crop, cotton, for money to buy the rest of life's necessities for this family of fifteen children. Mary Jane McLeod was the first to be born at the Homestead; and soon she had two more sisters.

There's no telling all the skills and abilities Mary inherited or learned from her parents, but they included the importance and value of hard work. As a child she worked in the cotton fields along with her brothers and sisters. One of her early memories was of picking about 250 pounds of cotton a day, and being hitched up to the plow to turn the soil when the family's mule died. Mary was very strong, and quite capable at cooking and other household chores, like laundry. Mrs. McLeod needed a lot of help with this because in addition to having a large family, she did laundry for local white people.

The McLeods were very sincere Christians. They passed their faith onto their children, a faith bound up in the high call of social service. The McLeods exhibited their commitment to the Gospel of Jesus Christ by such things as opening their home to their

neighbors for worship services. They further practiced what the Gospel preached by sharing food and other goods with their neighbors and people who were just passing through, regardless of color or creed. If someone needed something and the McLeods had it, they gave. Well before she was a teenager, Mary Jane McLeod was rooted and gounded in the principle of do-for-self—and do-for-others, too.

And Mary was hungry for learning. It was a hunger that had been aroused when she was a child. Another of her memories from childhood was an incident that occurred when one day she went with her mother to deliver a load of laundry. The customer's granddaughter let her play with her toys, among which was a book. When Mary went to hold this book in her hands, another child chided her with: "Put that down. *You* can't read." But Mary would learn.

When in 1882 a missionary named Emma Wilson opened a school in Mayesville's Trinity Presbyterian Church, Mary was more than eager to attend. As was true of countless other African-American girls and boys, Mary's parents had taught her what David Walker had meant when he said in his *Appeal:* "For colored people to acquire learning in this country makes tyrants quake and tremble on their sandy foundation."

Walker had written this in 1829, but when Mary McLeod was growing up in the 1880s, not a lot had

changed. During Reconstruction, many whites from the North had organized and supported schools for African Americans, but the overwhelming majority of white Southerners were staunchly opposed to this. As historian John Hope Franklin said, education was "the greatest single opportunity to escape the indignities and proscriptions of an oppressive white South." This is the last thing a great many white people wanted to happen.

African Americans and white Northerners worked hard building schools during Reconstruction, and they faced enormous dangers in the process. The Ku Klux Klan and other white supremacist groups worked just as hard to force schools to close: Schoolhouses were burned down; teachers and students were beaten, and some were murdered. Hundreds of African Americans who went to school in those days not only sacrificed their time and a little bit of money, but also their blood.

Mary McLeod did not experience such violence when she went to school, but her going had its hardships. Her school was about five miles away, and she had to walk each way; at the end of the day, in addition to homework there was housework to do as well. After she graduated from the Trinity Presbyterian Mission School for Negroes in 1886, with a head full of knowledge she would share with her family, she was

once again a full-time worker at the Homestead. There was no high school for African Americans in the area. Mary thought that all the schooling she had gotten would be all she would ever get. But then one day her former teacher, Emma Wilson, paid the McLeods a visit, bearing some very good news.

There was a scholarship to Scotia Seminary (now Barber-Scotia College), in Concord, North Carolina. It was a gift from a Quaker woman in Denver, Colorado, named Mary Chrissman, who had heard of the work Emma Wilson had been doing at her school and wanted to give a promising student a chance to build on the foundation Wilson had laid. Mary McLeod had been chosen, and her community rejoiced along with her, helping her with clothing and other necessities. When she boarded the train on a fall day in 1887, a crowd of well-wishers were at the station bidding her Godspeed.

Mary didn't get a free ride at Scotia. The Chrissman scholarship did not cover all her expenses, just tuition. Mary worked off the bill for room and board by doing laundry and janitorial work at the school. Money was so tight that she was unable to go home for the holidays. During summer vacation, for the next few years, Mary worked as a domestic in North Carolina, in Pennsylvania, and in Virginia. When school was back in session she continued to work at odd jobs at

Scotia and around town. Through it all her studies never suffered. English was her best subject, and her love of music and her sweet soprano voice were cultivated.

As she approached graduation, Mary made steps toward moving on to what she had long believed was her calling. To be a teacher would have been anyone's guess, but this wouldn't have been quite right. For all these years, Mary McLeod had been readying herself for service as a missionary in Africa. As she wrote to the Moody Bible Institute when applying for admission:

> It is . . . my greatest desire to enter your Institute for the purpose of receiving Biblical training in order that I may be fully prepared for the great work which I trust I may be called to do . . .

The Moody Bible Institute, in Chicago, Illinois, founded in 1886 by evangelist Dwight L. Moody, was one of the leading training grounds for Christian workers.

Chicago was a big, active city. It had some of everything, including rivers of poor African Americans who had been among the many who had come to the North looking for jobs and relief from the terrors of the South. While some had prospered, others, bunched up

on the city's Southside, had not. Although her sights were set on helping black Africans, McLeod did not ignore the plight of her fellow black Americans. She visited them in jails and in their squalid apartments. She comforted them with her singing and with the Word.

After a year's study, she went to the Presbyterian Board of Missions in New York, seeking a post in Africa. Her request was denied. The reason? The board was opposed to sending African-American missionaries to Africa. It had been the ambition of her life! And now ". . . the greatest disappointment in my life," is how she would describe it.

Hopes dashed, heart and mind in confusion, Mary McLeod returned south and to her alma mater (by then Mayesville Institute), where she served as assistant to her former teacher Emma Wilson. It wasn't long before she was transferred to Haines Normal and Industrial Institute in Augusta, Georgia. Haines had been started by the dynamic Lucy Laney, who allowed McLeod a good deal of freedom in her teaching. Classwork went beyond the discussion and memorization of Scripture. McLeod's students went to the community of the poor, delivering clothing and other necessities people had donated to the school. When McLeod transferred to Kendall Institute in Sumter, South Carolina, she instituted the same kind of

program there. At the same time, she was assisting her family with money so that her two sisters could go to school and her parents could dig themselves out of debt.

It was in Sumter that Mary McLeod met Albertus Bethune, whom she married in May 1898, and followed to Savannah, Georgia, where he had secured a teaching job, and where their only child, Albertus McLeod Bethune, was born. This marriage was apparently not a match made in heaven. Although they never divorced, their marriage was essentially over early on.

While it was normal for a husband to leave home for work wherever he found it, rarely did a wife do this. When a Presbyterian minister visiting from Palatka, Florida, who had heard about her fine work at Haines and Kendall, offered her a job at his church's school, Mary McLeod Bethune said yes. With her husband's lukewarm blessing, she was soon on her way to Palatka with Albertus, Jr. There, she supplemented her income from teaching by selling insurance for the Afro-American Life Insurance Company, in Jacksonville.

During her years in Palatka, Bethune helped to start two schools, and made time for other good works such as ministering to prisoners. Then one day in 1903 she saw an opportunity to do even more fifty miles southeast, where ditches were being dug and track was being laid for the Florida East Coast Railway. Much of the

labor would be done by African Americans who were pouring into Daytona Beach, where the major construction on the railroad was going on. With the influx of migrant workers and their families, Daytona Beach's African-American community would need a good school, Bethune reasoned. How else to break the cycle of poverty? What better way to empower the children of these workers to do more with their lives than follow in their parents' footsteps as cheap labor? The Presbyterian Board of Missions' rejection almost a decade ago would turn out to be one of the best things that ever happened to black America.

Bethune journeyed to Daytona Beach to investigate the viability of starting a school, and within a few days she made up her mind to go ahead. Not because she had guarantees of funding or other kinds of tangible support, but because her faith had been encouraged by a dream she'd had a few nights after her arrival. As she slept, she had a visit from one of her idols, Booker T. Washington, whose Tuskegee Normal and Industrial Institute in Alabama had become the model for many schools. In the dream, by a riverside, Washington handed her a diamond, telling her that it was for her school. Bethune took this as a sign that a way would be made for her to build her school, and she proceeded, operating totally on faith in God.

Bethune's Daytona Educational and Industrial

Training School for Negro Girls was founded in October 1904. It had very humble beginnings: threadbare quarters in a small house; starting capital in the amount of $1.50; a student body of five girls ages eight to twelve, and one little boy—Bethune's son. With regard to the furnishings and other supplies she and her students would need, Bethune had faith that these things would be provided, somehow. She did not, however, sit around waiting for manna from heaven. Bethune put hands and feet to her faith. As she recounted years later:

> We burned logs and used the charred splinters as pencils. For ink we mashed up elderberries. Strangers gave us a broom, a lamp, some cretonne to drape around the ugly packing-case which served as my first desk. Day after day, I went to the city dump and visited trash piles behind hotels, looking for discarded linen and kitchenware, cracked dishes and shattered chairs. I became adept at begging for bits of old lumber, bricks, and even cement. Salvaging, reconstructing, and making bricks without straw, were all part of our training.

Bethune was ingenious in the art of make-do. She was also a very resourceful and diligent fund-raiser. Her strategies included selling pies; rallying her community to sell dinners on behalf of the school; asking

locals to donate some of their harvest or catch of the day; and touring the town with the school choir for any loose change pleased listeners might give. Sometimes she simply asked for money without offering anything in exchange—except her assurance that she would build girls' minds and talents so that they would grow up to be self-sufficient, fruitful, decent women. "They will be trained," she promised, "in head, hand and heart: Their heads to think, their hands to work, and their hearts to have faith." When it came to raising money for the school, Bethune was tireless:

> *I rang doorbells and tackled cold prospects without a lead. I wrote articles for whoever would print them, distributed leaflets, rode interminable miles of dusty roads on my old bicycle, invaded churches, clubs, lodges, chambers of commerce. If a prospect refused to make a contribution I would say, "Thank you for your time." No matter how deep my hurt, I always smiled. I refused to be discouraged, for neither God nor man could use a discouraged soul.*

Many trusted in Bethune, contributing pennies, nickels, dimes, dollars—and whatever else they could toward this school whose student body grew and grew, and grew.

In 1907 Bethune went in search of more space, finding a tract of land serving at the time as a city

dump. After negotiating the purchase price down from two hundred and fifty to two hundred dollars, she persuaded the owner to agree to a payment of five dollars down and five dollars a month. This dump was known as "Hell Hole," but Bethune soon changed that. In time the dump was transformed into a thriving garden, with a dormitory and several small cottages for courses in such trades as rug-weaving and broom-making. There was also a hospital (named after Bethune's mother), and a farm on which students grew food for their own table and to sell at market.

Faith Hall is what Bethune named the school's main building.

By 1922 the school was a solid, vigorous place of learning, with about three hundred students, including more than a handful of boys, which led Bethune to change the name to Daytona Normal and Industrial Institute. These boys would soon have more male companionship, because in 1923 Bethune agreed to a merger of her school with the Darnell Cookman Institute in Jacksonville, creating the institution that eventually became Bethune-Cookman College.

What Bethune had accomplished in twenty years was a major achievement by anyone's standards. As Elaine E. Smith explains in her profile of Bethune in *Notable Black American Women:*

*Bethune conducted her institute in the head-heart-hand tra-
dition. . . . Initially, intellectual fare translated into in-
struction to the eighth grade, but after World War I it
included a high school incorporating teacher-training. From
1911 to 1927, through the institute's hospital, a re-
spectable nurse training course was offered. Heart education
at the school meant worship, Bible study, and temperance
training. But it also meant outreach programs; farmer con-
ferences on campus, a mission school in a turpentine camp, a
summer school and playground for local children, and com-
munity holiday projects. Hand education centered on pro-
ducing and handling food and then sewing.*

To some people today it might seem as if Bethune
did not encourage young people to set their sights very
high. Not true. She was doing her best to prepare them
for the realities of the society in which they lived. Even
though this was the twentieth century, very few African
Americans had the opportunity to pursue such careers
as architect, attorney, or engineer. It was a major feat
when one was given a job at the post office above that
of janitor. There were many college-educated men who
were porters for the railroad, and women, with, for ex-
ample, the ability and ambition to be physicians, who
were flatly denied admission into medical schools. In
the days when Bethune's school was on solid footing,
most African Americans were on the bottom of the

economic ladder, eking out a living as sharecroppers and domestics in the South, and as laborers and servants in the North. With the education Bethune offered, more African Americans in the next generation would be able to attain a better standard of living as skilled workers, artisans, teachers, and semiprofessionals. Equally important, graduates of Bethune's school would have more to pass on to their children, preparing them to excel as opportunities opened up.

As Bethune was building this institution, she also had been building her base of support, attracting donations from wealthy white people, both those who lived in Florida and those who only wintered there. Among her local supporters were the very rich members of the Palmetto Club, a social and philanthropic women's organization. Bethune's supporters from the North included industrialist John D. Rockefeller, Sr., and James N. Gamble, of the household products manufacturing company Proctor and Gamble, of Cincinnati, Ohio. Another major benefactor was Thomas H. White, of Cleveland, Ohio, owner of White Sewing Machine Company. His generosity toward the school was sparked during a visit where he saw students working on a Singer sewing machine— his main competition—whereupon he promptly donated one of his machines, and then followed up with much more. It was he who was largely responsible for

the completion of Faith Hall, and who inspired James N. Gamble to contribute heavily toward the purchase of a house that became Bethune's home, "The Retreat."

"For I am my mother's daughter," Bethune wrote in 1941, "and the drums of Africa still beat in my heart. They will not let me rest while there is a single Negro boy or girl without a chance to prove his worth."

Bethune did not spend a whole lot of time at The Retreat or anywhere else being idle. Bethune-Cookman College was just one of her accomplishments. Among the other ways she spent her time and energy were:

- 1924–28   President of the National Association of Colored Women (NACW)
- 1935–49   President of the National Council of Negro Women (NCNW)
- 1936–43   Director of the National Youth Administration's Division of Negro Affairs
- 1936–43   Member of the Federal Council of Negro Affairs
- 1936–51   President of the Association for the Study of Negro Life and History

Bethune made a mark in all of these positions. However, her most far-reaching work was with the

NACW, the NCNW, and in President Franklin Roosevelt's administration.

As president of the National Association of Colored Women, Bethune put her fund-raising expertise to work so the organization could purchase a building that would serve as its national headquarters in Washington, D.C. Now the organization would literally have a presence in the nation's capital. "Lifting as We Climb" was the NACW's motto, and Bethune pushed her ten thousand sisters to not limit their "lifting" to the local arena, but to broaden their activities to the national level. She also pushed the organization to think interracially and globally. The NACW was the strongest black women's organization in the United States and in the world at the time. But it was not the only one: There were dozens of others around the nation, with a collective membership of about eight hundred thousand. What if all these groups were to have an umbrella organization? Bethune wondered.

In November 1935 Bethune gathered together with a group of other women to discuss the formation of just such a group. They met at New York City's exclusive Waldorf-Astoria Hotel, which refused to serve them. Bethune's formidable fuss made them change their minds. This incident was relatively mild compared with the discrimination other African Americans

experienced on a daily basis. With her "superorganization," Bethune would tackle it all, as well as women's rights. The mission of this new group, the National Council of Negro Women, was manifold. Among its primary objectives was this: "To educate, encourage and effect the participation of Negro women in civic, political, economic and educational activities and institutions."

Before long the National Council of Negro Women was being recognized nationally and internationally as *the* voice of African-American women. And Bethune was being recognized as one of the most important leaders in black America. In 1935 a group of newspapers hailed her as one of the most influential women in the United States. The NAACP awarded her its prestigious Spingarn Medal.

Bethune was her people's "friend at court" when it came to government affairs. Her most historic position was as a member of the Federal Council on Negro Affairs, President Franklin Roosevelt's cluster of advisers on issues pertinent to black America. The group was nicknamed the "Black Cabinet." Of all her colleagues, Bethune's words carried the most weight. This was due to who she was and all that she had done, and it did not hurt that she had a friendship with the First Lady, Eleanor Roosevelt, a serious advocate of civil and women's rights.

President Roosevelt was committed to the advancement of all Americans. That is what his New Deal policies were all about. With Bethune around, black America would not be left out of the program. Thus, for example, through her work with the National Youth Administration, a job training and job placement agency for people ages sixteen to twenty-four, roughly five hundred thousand African-American youths received almost as good a deal as their white counterparts.

Bethune stepped down from the presidency of Bethune-Cookman College in 1943. Her chronic asthma was beginning to take a toll on her activities. She cut back, but she did not cease. Among the ways she did not rest was serving as adviser to various civic and educational organizations and institutions, and being black America's representative to several national and international events and conferences, including the April 1945 fifty-nation conference in San Francisco, California, from which would emerge the United Nations.

Mary Jane McLeod Bethune suffered a fatal heart attack on May 18, 1955. Three months later, in August, *Ebony* magazine published her "bequest" to her people, entitled "My Last Will and Testament," which she had completed shortly before her death. As the editor's note that accompanied *Ebony*'s reprint of the

piece years later states, it is, indeed "one of the great documents of our time and as relevant today as it was" when she wrote it. Here is some of what she "left" her people:

> *I leave you love.* Love builds. It is positive and hopeful. It is more beneficial than hate. . . . "Love thy neighbor" is a precept which could transform the world if it were universally practiced. . . .
>
> *I leave you hope.* . . . Yesterday, our ancestors endured the degradation of slavery, yet they retained their dignity. . . . Tomorrow, a new Negro, unhindered by race taboos and shackles, will benefit from more then 330 years of ceaseless striving and struggle. . . .
>
> *I leave you a thirst for education.* Knowledge is the prime need of the hour. . . .
>
> *I leave you faith.* . . . Without faith, nothing is possible. With it, nothing is impossible. Faith in God is the greatest power, but great, too, is faith in one's self. . . .
>
> *I leave you racial dignity.* I want Negroes to maintain their human dignity at all costs. . . .
>
> *I leave you finally a responsibility to our young people.* The world around us really belongs to youth for youth will

*take over its future management. Our children must never lose their zeal for building a better world. They must not be discouraged from aspiring toward greatness. . . .*

Not too many years after her death, owing to the work of one of her protégées, Dorothy Height, who became president of the National Council of Negro Women in 1957, work began on the creation of the Mary McLeod Bethune Memorial, to be placed in Washington, D.C.'s Lincoln Park. It would be the first monument honoring either a woman or an African American in a public park in the nation's capital.

This monument, unveiled in 1974 and which faces the Capitol Building, is composed of three figures: Bethune herself with a girl and a boy. The twelve-foot-tall bronze statue of the indomitable Bethune in her senior years looks ahead, as if into the future, as she hands her legacy, represented by a scroll, to the two young people.

# Clara Hale

On a spring afternoon in 1969, a woman named Lorraine stopped at a red light on a street in central Harlem, in New York City. She had just come from a short visit with her mother, who had given her "some lemonade and a listening ear" for her troubled soul. The young woman, a special education teacher and guidance counselor in the New York City public school system, was feeling that she was not making enough of a difference in the lives of young people. She was going through her frustrations as she waited at the red light, and thinking, too, about her mother's standard advice: "Lorraine, God put you on this earth for a reason. He's going to reveal that reason to you. Just wait. And keep your heart open so you'll see it when He puts it in front of you."

All Lorraine could see at the moment was her own turmoil. Then, something caught her eye.

It was a woman in a strange state. On a crate. Near

the curb. In her arms, there was a bundle. Lorraine thought she saw a little arm.

The car behind her beeped her to awareness that the light was now green. Lorraine drove on, but something within would not let her drive away. She circled the block and came back to the spot, parked, and got out of the car. As she drew nearer to the woman, Lorraine was certain that the bundle was a baby, and that the woman was on drugs, lost in a heroin nod.

It was a sad sight, and these were very sad times in Harlem. Indeed, 1969 was a very sad time around the nation. Many people were in low and bitter spirits. In the previous year there had much mourning.

On April 4, 1968, the Reverend Martin Luther King, Jr., great healer and testament of hope, was assassinated. Three months later, on June 5, another champion of the causes of the poor and oppressed was slain: New York Senator Robert F. Kennedy, younger brother of President John F. Kennedy, who had been assassinated in 1963. "Bobby," as he was known, was killed while on the campaign trail for the presidency, and many Americans thought he would surely keep hope and justice alive, building on some of the policies of President Lyndon Baines Johnson, who had already announced that he would not seek reelection.

In 1964 President Johnson had declared a "War on

Poverty," a battle to be fought with job training, new and improved housing, and other propeople measures. He had said yes to the Civil Rights Acts of 1964 and 1968, which prohibited discrimination in public accommodations, employment, and housing. In continuing the New Frontier policies of John F. Kennedy, for whom he had served as vice president, Johnson had named his vision of a better nation the Great Society. His vision, however, was never realized. In the 1968 presidential election, instead of choosing then Vice President Hubert Humphrey, the candidate most likely to press on with the goals of the Great Society, the majority of voters cast their ballot for the Republican candidate, Richard Nixon. So, by 1969 the Great Society was a lost cause, and the Harlems of the nation were especially sad places to be.

Harlem, "the capital of Black America," had indeed seen much better days. Her longtime fighting Congressman the Reverend Adam Clayton Powell, Jr., pastor of the Abyssinian Baptist Church, had been weakened by political problems and sickness, too. Added to this, in the wake of the social and economic gains made during the civil rights movement of the 1950s and 1960s was that many achievers left Harlem for greener pastures. They moved to New York's outer boroughs of Queens and the Bronx, to towns in Westchester County, and to the Garden State, New

Jersey. The flight of the middle class drained Harlem of many everyday role models and stabilizing forces.

One of the most formidable foes in Harlem was drug abuse, on the rise throughout the nation. Heroin, in particular, had a fierce hold on increasing numbers of people.

Lorraine could not *not* help this woman. What if in her stupor she let the baby slip onto the hard concrete? What if the bundle rolled into the street?

"My mother will help you," Lorraine said to the woman. "She loves babies and it would give you a chance to get yourself together." Lorraine then pressed into the woman's hand a piece of paper on which she had been scribbling something as she spoke. "Here, go to this address," Lorraine urged.

This Lorraine is Dr. Lorraine E. Hale, who recounted this moment in *Hale House: Alive With Love*, the short and sweet story of the beginnings of a place where miracles have happened, where infant lives have been transformed.

The woman took Lorraine's advice. She went to Clara Hale, and ended up leaving the baby girl with her, to be cared for and eventually named Amanda.

Clara Hale truly did love babies, but Amanda was the last thing she wanted in her life. She was actually quite upset with Lorraine when the woman appeared at her door saying her daughter had sent her. Clara Hale

was sixty-five years old at the time. She was looking forward to retirement, to relaxing and doing as she pleased with no one to take care of except herself. If anyone deserved a long stretch of rest and relaxation it was this small, wiry woman who had known very little leisure in her life.

She was born Clara McBride on April 1, 1905, in Philadelphia, Pennsylvania. She was the youngest of her parents' four children, but she never knew her father because he died when she was a baby. After her husband's death Mrs. McBride supported the family by taking lodgers into her home. Clara may have known hard times as she was growing up, but her Baptist rearing kept her out of trouble and on the positive track. One significant indication of this is that she graduated from high school, something that many people did not do (or even reach for) when Clara was a teenager.

Clara McBride began a new life when she married Thomas Hale. The couple eventually moved to New York City, where he started a floor-waxing business and she helped make ends meet by cleaning theaters. They were intent on not just getting by but on paving the way for their children, Nathan and Lorraine, to have a better life. Part of their program was Mr. Hale's attendance at City College at night. But six months after he graduated from college, and not long after the birth of their third child, Kenneth, Mr. Hale died. As

the family's sole support now, his twenty-seven-year-old widow had to make more money. She added domestic work to her janitorial jobs.

It grieved Clara Hale that supporting her children meant being away from them for so many hours of the day and night. She searched for a solution and found it in foster care: She could earn a living taking care of other's people's children and be at home with her own at the same time. This turned out to be a very workable solution, and over the next twenty-odd years Clara Hale raised more than forty children. Her impact on these young lives was profound. As she remembered years later in an interview for the book *I Dream a World: Portraits of Black Women Who Changed America:*

> *Every one of them went to college, every one of them graduated, and they have lovely jobs. They're some of the nicest people. Anything they wanted to do, I backed them up. I have singers, dancers, preachers, and things like that. They're schoolteachers, lawyers, doctors, anything else. No big name or anything, but they're happy.*

Considering all that she had done to help others pursue happy lives, no one would begrudge Clara Hale's desire to retire. But little, abandoned Amanda ushered her into a renewed career. Certain that the baby's mother was not going to return for her, Clara

Hale took Amanda into her own life. It wasn't long before word of her act of compassion got around.

People have always been known to take in a friend or relative's child in an emergency; but rare are those who will take in a stranger's child, especially when that stranger is a drug addict. Before the summer of 1969 was over, Clara Hale had twenty-two babies in her small five-room apartment, all of them born to drug-abusing women. The babies were days old to over one year old, not only in need of food, shelter, and clothing, but also of someone with the patience to hug and rock and bear with their crying during their long days and nights of awful withdrawal from drugs.

There was a time when many people did not believe that a baby could be born a drug addict. Clara Hale knew better, firsthand. Depending on how heavily the mother had been using drugs and how close to the time of delivery she had last taken some drugs, the baby might suffer anything from mild discomfort to extended bouts of serious sickness: diarrhea, vomiting, breathing trouble, hyperirritability, seizures. A baby could be in the throes of withdrawal for as short a time as a few days or for as long as several months. And since drug-abusing mothers give little or no thought to nutrition and rarely seek prenatal care, their babies are apt to be born with other deficiencies and defects of body and mind. Such was the early life of

the babies brought to Clara Hale's door. Babies like "Tiny Ty," a newborn whom Lorraine Hale remembered thusly:

> *Angels must have caught him the night his drug-addicted mother pitched him in the dumpster. It was filled with broken wine bottles and splintered furniture. Yet he fell on the one soft thing in it; a piece of discarded carpet that smelled of wine. Fortunately, only a few mosquitoes and roaches had bothered him. . . .*
>
> *It was truly a miracle that he had beaten the odds of dying from exposure those critical first hours of his young life.*
>
> *And now he needed us to help him beat a more determined foe: heroin, his birth companion. The "monkey on his back."*

Caring for a healthy baby is a very time-, energy-, and money-consuming task. Caring for one in physical and emotional agony is doubly so. Clara Hale's selflessness and remarkable gift for nursing and nurturing makes it easy to understand why she came to be known as "Mother Hale."

For the next few years with the financial and physical support of Lorraine and additional financial assistance from her two sons, Clara Hale went on to help dozens of children beat the monkey on their back.

They were children of various races and ethnicities. They were children who came to her in various ways: Some were simply left at her door; others were handed to her by their mothers in a desperate effort to get their children the help that they knew they could not provide. These children were all addicted to various substances: alcohol, heroin, methadone, cocaine.

In the early 1970s Clara Hale received relatively small sums of money from New York City to help with expenses of taking care of these babies. In 1973, with her daughter as executive director, she founded the Hale House Center for the Promotion of Human Potential, thus officially becoming the first not-for-profit nursery for drug-addicted children. Mother Hale had no more thoughts of retirement, and her daughter definitely had found her calling.

In 1975 Hale House moved to a five-story brownstone on West 122nd Street. This house that love built would become a multiservice organization, giving intensive, personal care to about twenty children at a time. It had a staff of more than two dozen dedicated men and women—from those who cooked the babies good food to child care specialists and medical professionals, including a psychologist and speech therapist. Hale House further helped the children through its relationships with local clinics and various social service

agencies. By the early 1980s Hale House had seen to the physical and emotional needs of about six hundred children.

One of Hale House's great hopes was to see families whole and healthy, so they referred the mothers of their charges to places where they could obtain help for their drug addiction and other problems. In the majority of the cases—over ninety percent of the time—the women did turn their lives around and were able to one day truly mother their children. When a mother died or disappeared, the Hales did all that they could to find a relative willing and capable of taking good care of the child. In those instances where foster care or adoption was the only option, they did their best to see that a child went to responsible, loving people.

By the mid-1980s Hale House was making a major difference in many lives, not just in the lives of the sick and broken, but the well, too—for Mother Hale inspired others around the nation to be more compassionate. Some started similar programs, while others became faithful financial supporters of Hale House. And funding was always an issue. Hale House had never received major funding from the government, but relied heavily on the generosity of private citizens, churches, and civic-minded corporations.

In spite of money woes, Hale House carried on,

and its needs only increased. By now Hale House was becoming home to more and more babies who were not only addicted to drugs, but who also had been born with a mysterious disease that would make their care more costly. These were babies with AIDS (acquired immune deficiency syndrome), the final stage of HIV (human immunodeficiency virus), which can either merely weaken or totally destroy the body's ability to effectively fight disease.

Linda was Mother Hale's first AIDS baby. She had come to Hale House because she was born with a cocaine addiction. As Lorraine Hale recounted:

> It took two months after her arrival at Hale House for all the symptoms of drug withdrawal to disappear. Thin and sickly, mostly with colds and fevers, Linda had to be seen at the local clinic at least once a week.
>
> She and Mother had a special relationship going that included various games. When Mother called her name, her eyes, so alert, would brighten and widen. I laughed and laughed at her reaction. It was always the same, no matter how many times they played it.

Several months later, and after numerous stays in the hospital, it was discovered that Linda had been exposed to the AIDS virus. About one-third of the babies born to women with HIV are born with the virus.

Some grow up in relative good health. Others die young.

At the time Linda was diagnosed, many people reacted to those with HIV and AIDS the way people reacted over the ages to lepers: Don't touch. A hug, a kiss, or even a teardrop might give them the disease, they feared. The Hales were deeply saddened when they discovered that members of the Hale House team thought like this, and that they did not want Linda to return to Hale House.

Mother Hale and Lorraine held fast. Although she was not greeted with open arms by everyone, Linda did return to Hale House. She was put in a room alone, with only Mother Hale, Lorraine, and another child care worker to tend to her.

In the face of the AIDS crisis, Mother Hale's love for and commitment to the neediest children only strengthened. In the late 1980s she stated:

> *I'm not going to retire again. Until I die, I'm going to keep doing. . . .*
> *We're going to open a place for children with AIDS. . . . People shun them and it's not their fault. I want them to live a good life while they can and know someone loves them.*

Through the referrals of neighbors, ministers, social workers, police officers, and other civil servants,

the children continued to come to Hale House. With their drug addictions. With their AIDS. People marveled at Mother Hale, who, now in her eighties, still had the patience and the stamina to, day after day, feed, clean, rock, and walk the floor with these sick and suffering babies.

Those are the children Mother Hale chose to love.

What kept her going? "We gain strength from the love we give," she once said, "and the love it generates."

When Mother Clara Hale died in December 1992 at the age of eighty-seven, Hale House had helped close to one thousand infants, toddlers, and preschoolers. She had seen some of her children grow up to be healthy, and others who had not done so well. Of those who died very young there was peace in the knowledge that while at Hale House they had known tenderness and mercy. Lorraine Hale, imbued with a double portion of her mother's spirit, has continued in her Hale House work.

In 1994 the model for the Mother Hale Memorial was unveiled at New York City's Riverside Church. In his testimony to Clara Hale's long years of service to the young, the church's senior minister, James A. Forbes, Jr., remembered her as one who "taught us the art of guiding little feet across bridges, over troubled waters and landing them safe on a solid rock."

During her lifetime, people around the world had applauded and praised Clara Hale for her work. She had received numerous awards, including the Leonard H. Carter Humanitarian Award, in 1987, and the Booth Community Service Award, in 1990. These were the highest awards of the Salvation Army, founded in 1865 to minister to the bodies and spirits of the poor, with a special focus on alcoholics, in the early years, and later, drug-sick souls, too.

Mother Hale has been called a saint, a miracle worker, a blessing to the nation. In his 1985 State of the Union address, President Ronald Reagan had hailed Mother Hale as an "American hero."

In an interview some time later, she, ever humble, said: "I'm not an American hero. I'm a person that loves children."

# Leontyne Price

To make a career as a singer is not easy. To make it as an opera singer is much more of a mountainous journey, because the training is intense, the sacrifices of time and personal pleasures are enormous, and the opportunities for performance are far fewer than in popular music. To be a black person in pursuit of a career in opera is like climbing Mount Everest in a blizzard.

When she was born on February 10, 1927, no one could have predicted that Leontyne Price would make that climb, let alone reach the top. A little African-American girl from Laurel, Mississippi?

There is no state in the union that has ever been a heaven for African Americans, but Mississippi has historically ranked high among the most torturous. What's more, Price grew up in Mississippi during the Great Depression, which left millions of Americans jobless, homeless, and hopeless in the 1930s and early 1940s. Her parents, however, who had known dreams deferred, saw to it that neither racism nor the

Depression would sour the hearts of their daughter and of their son, George.

Price's mother, Katherine Baker Price, had set her sights on becoming a nurse, which led her from Fernando, Mississippi, to Holly Springs to attend Rust College. Money failing, she had to forego her education, and moved in with her sister and brother-in-law in nearby Laurel. Mrs. Price, whom her daughter would one day call her "greatest inspiration," eventually became a very respected midwife in her town and in the surrounding area. "My first hero," is how Price summed up her feelings for her father, James Anthony Price, a carpenter who supported his family through long, hard hours at a sawmill.

Though her mother never realized her dream of being a nurse and her father never had his own shop, they certainly imparted to their children the principle of seeking success in all that they did. As Price once reflected: "The words 'do your best' was the constant echo we heard, and that was all we did."

George grew up to have a distinguished career in the military, retiring as a brigadier general. As for his sister . . .

Mr. and Mrs. Price, both children of Methodist ministers, passed on to their daughter their love for music and their musical abilities cultivated in the church. Where the Price family worshiped, Saint Paul's

Methodist Church, Daddy played the tuba in the band, and Mama was a member of the choir.

Leontyne was attracted to music at a very early age. She began studying piano when she was three and a half, with a local pianist, Hattie McInnis, and it wasn't long before Mr. and Mrs. Price brought a real piano into their home. Their daughter practiced, practiced, practiced. This bore fruit in her participation in the musical programs at Sandy Gavin Elementary School, where it became clear that, for her, music would not be a passing fancy. A magic moment came at age nine, when Mrs. Price took her to Jackson, Mississippi, for a concert by the great contralto Marian Anderson, one of the nation's most celebrated and ground-breaking performers. Her impact on Price was everlasting:

> *When I first heard Marian Anderson, it was a vision of elegance and nobility. It was one of the most enthralling, marvelous experiences I've ever had. I can't tell you how inspired I was to do something even similar to what she was doing. That was what you might call the original kick-off.*

When at age ten she entered sixth grade at Oak Park Vocational High School, where her piano teacher taught, she was firmly on a musical track. As a member of the Oak Park Choral Group she sang first soprano and played piano for concerts. She also played and

sang for Saint Paul's Sunday school and at worship services, as well as at funerals, weddings, and other social events around Laurel.

She excelled in voice and piano and in her academic courses, graduating from high school with honors. Her diligence paid off in the form of a scholarship to one of the oldest historically black colleges, Wilberforce College (now University), in Wilberforce, Ohio, established before the Civil War, in 1856. Because of departmental changes at the college, Price transferred to Wilberforce's buddy school, Central State University, to take her major in music education, with great expectations of one day returning to Laurel to teach voice and piano. Other people, however, helped her to see that she had other possibilities.

One professor suggested she change her major to voice. Another helped her find her true voice. She had become accustomed to singing mezzo-soprano—midway between contralto (the lowest range of female voice) and soprano (the highest range). But this man pointed out that her best voice was lyric soprano—very light, very sweet, and very right for the professional singing career her mentors urged her to pursue.

Price threw herself into preparation for this—in her classes, and as a member of the college choir and a local church choir. Also, she was a featured soloist in the Wilberforce Singers, which, in the trailblazing

tradition of Fisk University's Jubilee Singers, traveled around the region for fund-raising concerts.

In 1948 twenty-one-year-old Price traveled to New York City to attend the prestigious Juilliard School of Music. Her parents were prepared to give her all the financial support they could, and she was prepared to work to help herself get through her graduate studies. Her attendance was assured with substantial assistance from a white family, the Chisholms, for whom an aunt worked. This family not only had watched Price grow up, but also often had her perform in their home. Additional moral and financial support was generated by Paul Robeson, the legendary bass-baritone concert singer and actor, who, because of his civil and human rights activism, was denounced by many Americans from the 1950s until almost the day he died in 1976. However, the year was 1948 when Robeson heard Price sing at a concert at Antioch College, and he was still a shining star. He offered to do a benefit concert, which netted a nice sum for this extremely promising soprano.

Being at Juilliard meant being so close to so much fine music—in small and large halls, and in the many theaters around New York City. For Price, opera became her goal after she saw a Metropolitan Opera production of Richard Strauss's *Salome*, based on the biblical account of the young woman who manipulated

King Herod into beheading John the Baptist. Her *Salome* experience moved Price to declare: "I have got to be an opera singer!"

This was the wish of a woman whose encounters with opera before her Juilliard days had been from afar: the Metropolitan Opera company's Saturday afternoon radio broadcasts, which she had listened to in her youth. But now—"I have got to be an opera singer!" What a bold wish that was indeed.

Opera, essentially a play in which actors sing their parts instead of speaking them, was born in Florence, Italy, in the late sixteenth century, and had become extremely popular across Europe by the eighteenth century. In the beginning, shows were relatively short and simple, with plots based on legends and ancient history. In time, productions became more lavish, with elaborate sets and costumes and large choruses and orchestras. Great works of literature were added to the mix of legends and historical events on which the stories were based; plots became more complex, involving more characters. Always, the star of the show has been the music, with the lead instrument being the voice—solo and group.

The world of opera did not open up to African Americans for a very long time. The prevailing attitude was, yes, we accept and applaud you singing the blues, and playing jazz and clowning and pop-dancing on

stage, but . . . opera? Many also assumed that African Americans could not possibly be interested in listening to or seeing opera. Yet stories abound of African-American children and adults sneaking into opera houses to listen, to learn; of their relishing opera on the radio and on recordings. There are accounts of musicians, like the great trumpeter Louis "Satchmo" Armstrong, who loved opera and whose compositions and playing, here and there, attest to this fact. There's also a history of African-American opera singers that dates back to the late nineteenth century, as evidenced, for example, by the formation of the Colored American Opera Company in Washington, D.C., in 1873, half a century before Leontyne Price was born. In years to come there would be others, including the Detroit Negro Opera Company, formed in 1938, and the National Negro Opera Company, formed in 1941.

African Americans made further inroads into opera in the mid-1930s with the birth of two out-of-the-ordinary operas by two white men who were fascinated with black culture. The first was *Four Saints in Three Acts* (1934), composed by Virgil Thomson. The story was not "black" in theme, but Thomson insisted it be performed only by an all-black cast. In 1935 came the production of *Porgy and Bess*, based on Du Bose and Dorothy Heyward's 1927 play *Porgy*, which was first a

novel. The opera's creator was the prolific composer George Gershwin, whose brother Ira wrote the lyrics for this story about life in Catfish Row, a fictional slum in Charleston, South Carolina, featuring a crippled beggar (Porgy) hopelessly in love with a "loose" woman (Bess), who is won over by Crown, a villainous gambler. Another major character is a hustler named Sportin' Life. With characters like these and the song "I Got Plenty of Nothin'," the refrain of which is "I got plenty of nothin' and nothin's plenty for me," *Porgy and Bess* was not something a lot of African Americans could applaud.

While some very talented African-American singers would then and later decline to be in *Porgy and Bess*, many seized the opportunity. For, like *Four Saints in Three Acts*, it could lead to bigger and better things. This proved true for a few, but most who made it only did so when they went to Europe to further their opera careers. Few opera companies in the United States wanted to open their stages to them. New York City's Metropolitan Opera—the grandest in the United States—maintained its no-blacks policy until 1950, when Janet Collins danced in Giuseppe Verdi's *Aida*. No black person sang at the Met until 1954, when Price's early idol, Marian Anderson, played Ulrica, the sorceress in Verdi's *Un Ballo in Maschera (A Masked Ball)*.

After Anderson a handful of other African-American singers appeared on the Met stage in the late 1950s, but none in a major role.

When Leontyne Price set her sights on opera, the debut of Anderson and the others was a few years away. Price essentially had to be her own role model.

She auditioned for Juilliard's Opera Workshop. The competition was stiff, but she was accepted. Now, Price had to do even more practice, practice, practice, and learn the ABC's of acting and the fundamentals of Italian and a few other languages in which she would be singing. Soon she had a minor role in an opera by Giacomo Puccini. Her second role was a major one: Mistress Alice Ford in Verdi's comic masterpiece, *Falstaff.*

One of the several people enchanted by this Mistress Ford was Virgil Thomson. At the time, he was preparing for a revival of *Four Saints in Three Acts.* Price became Saint Cecilia in a production that played in New York and Paris in 1952. Her next break came that same year when she was cast as Bess in a revival of *Porgy and Bess,* which toured in the United States and in Europe. *Porgy and Bess* also led to her marriage to baritone William Warfield, who played Porgy. The couple would separate after two years of marriage, divorcing years later.

Almost everywhere, Price's performance as Bess received rave reviews. Remarked one critic: "Her voice has purity, power and impact." Another declared that "Leontyne Price sings the most exciting and thrilling Bess we have heard," and predicted that she "will no doubt spend a long time in the role of Bess. But when she is available for other music, she will have a dramatic career."

It was her performance of Bess that caught the attention of NBC's musical director Peter Herman Adler. He was looking for someone to play the lead role of Floria Tosca in the upcoming NBC-TV Opera Workshop production of Puccini's *Tosca* (1955). Price would be the first black opera singer in a television opera production. What made the moment all the more dramatic was that the opera is a love story and the man playing Floria Tosca's beloved was white. Very risky on NBC's part, and one for which they paid a price. The network's affiliates in the South threatened not to air the program. About a dozen stations acted on the threat; but the opera went on. And Price did, too . . . to several more roles on NBC-TV and on to other stages, where she sang opera as well as other music. Wherever and whatever she performed, people took notice.

In 1957 she was cast in one of Giuseppe Verdi's

most popular works, in the role that she described as a "portrait of my inner self."

Aida.

Allegedly based on an historical event, it is a love story that takes place once upon a time in Africa. Ethiopia and Egypt are at war, and Aida, Princess of Ethiopa, is captured and, along with other prisoners of war, is taken off to Egypt to be a slave. While serving as the personal maid to Pharaoh's daughter, Aida comes in contact with a high officer in the Egyptian army, and the two fall eternally in love.

Price first performed *Aida* at the San Francisco Opera House in 1958. Repeat performances followed at home and abroad. Her total absorption in a role, her charisma, and her splendor were never so apparent as when she was portraying Princess Aida. Undoubtedly one of Price's most triumphant performances occurred in 1959 when she performed the part at La Scala, in Milan. Not only was La Scala Italy's preeminent opera house, it was also where *Aida*'s composer, at age twenty-six, had his first opera performed. It was an Italian critic who gave Price the glowing compliment: "Our great Verdi would have found her the ideal Aida." Over the years, many opera critics and legions of opera fans would wholeheartedly agree, as Price sang on the stages of other major opera houses and concert halls in the United States and abroad. The place she would

perform the role the most times was the place that became her "home opera house," the Met.

"Nice about Leontyne busting the wall of the Metropolitan wide open last night. Negroes and Italians do sing the most!" This is a line from a January 1961 letter from Langston Hughes, to his friend, writer and critic Arna Bontemps.

"Nice"? What a display of poetic cool.

Hughes was talking about Price's debut with the Metropolitan Opera on January 27, 1961, a milestone in African-American history. It was an especially momentous event because this production of Verdi's *Il Trovatore* was the Met's first opera of the season, and in it Price played the lead role of Leonora, one of the Queen of Spain's ladies-in-waiting, who is loved by a count but whose heart belongs to his long-lost brother, a traveling poet-musician—a *trovatore*, a troubadour. Price made history as well when at the close of the show the audience applauded for forty-two minutes—a Met record.

*It was my first real victory, my first unqualified acceptance as an American, as a human being, as a black, as an artist, the whole thing. . . . From Mississippi to the Met. That's the pinnacle. That forty-two minute ovation was like having climbed the mountain.*

What a night that was for Leontyne Price, and by morning she was her nation's first lady of opera.

Being a prima donna meant six more starring roles at the Met that season, and scores more in the years to come with this opera company and others. It meant sell-out concerts, many recording contracts, and honors galore. But it wasn't all glory. As someone once said, "days of maintenance are far more than days of magnificence." Maintenance meant careful, sometimes very guarded living—in diet, in social life, in environment. It meant continued discipline to do the hours of research required to really take on a role, and the practice, practice, practice of the music. And then, there were the demands, the pressures of being an African American.

Price came center stage in the opera world when there was still segregation throughout the South, where the Met toured. Her presence in the company inspired the general manager, Rudolf Bing (the force behind Marian Anderson's debut at the Met), to a new level of commitment. The Met would not perform before segregated audiences, and the company would not stay at hotels that would not give Price first-class treatment. In the North, there were walls to be broken down, too.

Although it may sound arrogant, her statement "I pioneer every time I open my mouth" was true. For almost every time she sang, she was doing so before audiences filled with many people who could appreciate

the talent but not the total package—not "the whole thing." A *black* prima donna?

Leontyne Price's rise coincided with some of the most epic moments in the 1950–60s civil rights movement. *Brown v. Board of Education of Topeka* in 1954 . . . the Montgomery (Alabama) bus boycott, in 1955 . . . Arkansas' "Little Rock Nine" school desegregation effort in 1957 . . . the passage of the Civil Rights Act of 1964, which resulted from the historic March on Washington for Jobs and Freedom in August 1963. And in 1963, there had been a benefit concert in Laurel, Mississippi, to raise funds for a new Saint Paul's Methodist Church. The concert was attended by some two thousand people, and it was given by Leontyne Price. This was Laurel's first integrated public entertainment event.

For all the progress made, there were still terrible things going on. In the same year that Price gave a concert in her hometown, Medgar Evers, head of the Mississippi chapter of the NAACP, was assassinated, and a few months later, in September 1963, there was the bombing of a church in Birmingham, Alabama, in which four little girls in a Sunday school class were killed. It was also in 1963 that Alabama's Governor George Wallace had made the vow "Segregation now! Segregation tomorrow! Segregation forever!" Two years

later, in March 1965, came "Bloody Sunday," as the day became known, on which six hundred people in a peaceful march from Selma to Montgomery, Alabama, were attacked on the Edmund Pettus Bridge, by state troopers dispatched by Governor George Wallace. For this reason, even in their bravos for Price, some African Americans were disappointed in her for not being more vocal about the violations against her people's lives. But Price maintained that in doing her work, in being her absolute best as a performer, she *was* making a statement.

Price made history again in 1966 when she starred in the world premiere of Samuel Barber's *Antony and Cleopatra*. This opera was the opener for the Met's new home at Lincoln Center, which would be the biggest opera house in the world. *Antony and Cleopatra* had been composed expressly for this occasion, and the role of Cleopatra tailored expressly for Leontyne Price.

Price's voice continued gloriously strong through the 1970s. Her prominence inspired and opened up opportunities for Kathleen Battle, Jessye Norman, Leona Mitchell, Cynthia Clarey, Gwendolyn Bradley, and other opera singers. Price was quite aware of her significance.

*I was the first black diva that was going to hang on. My being prepared is the reason I didn't go away. That is really*

*the substance of my pioneering. Marian [Anderson] had*
*opened the door. I kept it from closing again.*

Her magnificence was still very much in evidence in
the mid-1980s, but Price wanted to leave "standing up,
like a well-mannered guest at a party." She did not
want to overstay her welcome; she did not want to do
what too many performers do: go on and on until their
talent has faded, at which point people forget their past
glories and pity or laugh at them as has-beens.

On January 3, 1985, the Public Broadcasting
System's television broadcast of *Live from the Met* was a
splendid moment for millions of opera lovers around
the nation, especially fans of Price, because it was a
chance to see a great performance that they would not
otherwise have been able to experience. It was a time
for tears, too, however, because Leontyne Price was
saying farewell. And she did it as Aida. While the au-
dience applauded her sterling rendition of this opera's
most famous solo song, the aria known as "O patria
mia," (Oh, My Country), Price fought back the tears.
Wrote one critic some months later in *Opera News*:

*Perhaps the opera event of 1985 was the stage farewell of
Leontyne Price who bid adieu with* Aida *. . . on the stage
of the Metropolitan Opera—a fitting platform for the
Mississippi born soprano, who over the decades had become*

the *American prima donna personified. No natural born singer of her era has been so honored as Leontyne Price, and few singers of any nationality have captured the hearts of their public as she has over the years. . . .*

Leontyne Price had been the first opera singer to be given the Presidential Medal of Freedom. The birthplace of opera, Italy, had honored her with the Order of Merit, its highest award. Three Emmys and twenty Grammy Awards were among the many other coveted awards she had received by the time she retired.

When Price retired from the Met, she did not retire from music. She continued to give recitals, and found time for some teaching and for mentoring up-and-coming sopranos. One of the very special ways in which she spent some of her retirement days was working on a book for young readers published in 1990. It is her telling of the story of the opera dearest to her heart. In her closing note to this poignant and lavishly illustrated presentation of *Aida*, Price wrote:

Aida *has given me great inspiration onstage and off. Her deep devotion and love for her country and for her people— her nobility, strength, and courage—are all qualities I aspire to as a human being. I will never forget her.*

And the world will never forget Leontyne Price.

# Toni Morrison

The artistry Toni Morrison has displayed in her novels has been applauded around the world, most publicly and powerfully in the numerous awards she has received. Among the most impressive are the National Book Critics Circle Award and the American Academy and Institute of Arts and Letters Award, which she received in 1977 for *Song of Solomon*, and that most important of American honors, the Pulitzer Prize for Literature, awarded for *Beloved* in 1988. In 1993 Morrison garnered the most prestigious award a writer can receive: the Nobel Prize in Literature. This international award, granted annually by the Royal Swedish Academy of Sciences to a handful of people for outstanding achievement in the sciences and humanities, came with a gold medal and $825,000—plus the certainty that sales of her books would skyrocket.

For Morrison the Nobel Prize added up to more authority in the literary world and wider possibilities for her life. Her Nobel Prize, however, did not send

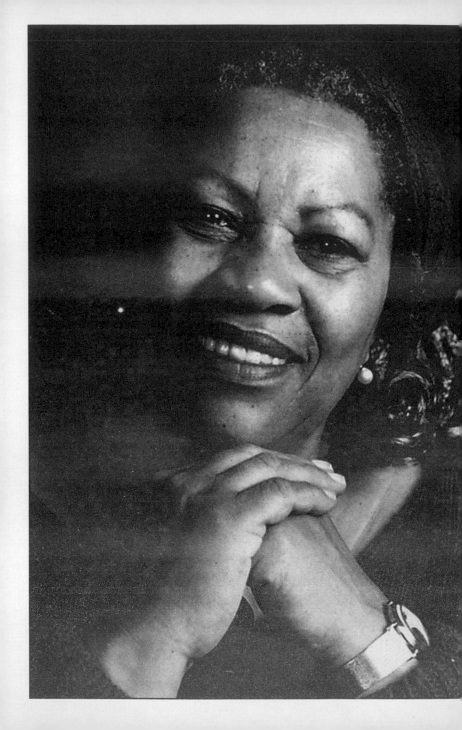

her into an ego spin. When she received the good news on October 7, 1993, one of the first public comments she made was that she was so glad her mother was alive to see this. At the close of her acceptance speech, delivered in Stockholm, Sweden, on December 7, 1993, she called the event "a moment of grace."

Morrison's winning of the Nobel Prize was historic. Of the nearly six hundred people awarded the Nobel Prize since its inception in 1901 (by Alfred Nobel, who invented dynamite), four had been black: diplomat Ralph Bunche (in 1950, for Peace); Martin Luther King, Jr. (in 1964, for Peace); Barbados-born Sir Arthur Lewis (in 1979, for Economics); and Nigeria's Wole Soyinka (in 1986, for Literature). Morrison was the fifth black person to win a Nobel, the first African American to win it for literature and the first black woman (and only the eighth woman) to receive this prize for anything.

Was the fame and fortune a childhood dream come true? No. As a girl, Toni Morrison did not dream of becoming a literary star; and as a girl, her name wasn't even Toni Morrison.

She was born Chloe Anthony Wofford, on February 18, 1931, in the small, gritty steel mill town of Lorain, Ohio, a suburb of Cleveland. Her parents, both children of sharecroppers, had migrated from the South with their families in the early 1900s. Her

mother, Ramah Willis, had been born in Alabama, and her father, George Wofford, in Georgia. The Willises and the Woffords had left the South for the same reason thousands of other African Americans had: to escape white violence, poverty, and poor educational opportunities.

Ohio was, in many ways, a much better place to be in than the states of the Deep South, but it was hardly a paradise. In reflecting on the contradictions of her home state, Morrison once commented:

> *The northern part of the state had underground railroad stations and a history of black people escaping into Canada, but the southern part of the state is as much Kentucky as there is, complete with cross burnings. Ohio is a curious juxtaposition of what was ideal in this country and what was base. It was also a Mecca for black people; they came to the mills and plants because Ohio offered the possibility of a good life, the possibility of freedom, even though there were some terrible obstacles.*

Dignity and diligence. These were the ideals Chloe and her three siblings were raised to maintain, in the face of obstacles and in the course of everyday living.

She was born two years after the stock market crash in 1929 and so grew up during the Great Depression. In these times of widespread misfortune, the Wofford

family was among the fortunate few who remained rock steady. Mr. Wofford worked as a welder at a shipyard and had two other jobs on the side. Supporting his family by any honest means available was what he did throughout his children's growing-up years. Mrs. Wofford occasionally did outside work, like laundry, to bring in extra money. Theirs was a strong family made stronger by the presence of Mrs. Wofford's parents.

George and Ramah Wofford trained their children to look ahead to a fruitful, stable life. At the same time, they taught them not to be afraid to look back at painful truths of the past. Along with their dreams for a better life, the Woffords had come to Ohio with memories of the hardships in the South, and they did not keep these truths from their children. These real-life stories would one day come to haunt their second child's fiction.

The Woffords also passed on numerous gems of black culture. These were often transmitted through storytelling, which was a family tradition, and somewhat of a national pastime in pre-TV days. Both Chloe's parents were masters of a good, old-fashioned, spine-tingling ghost story. They stirred Chloe's imagination, too, with folktales, such as those about the trickeries of Brer Rabbit and the treacherous and troublesome Tar Baby. Chloe was coaxed to ponder

impossibilities when hearing legends of Africans who once upon a time did incredible things. Like fly.

Song was a major influence in young Chloe's life. From her mother in particular, who was a member of the church choir, she learned the music of the black church—from the old-time spirituals to gospel. This music, rooted in African sounds and rhythms, connected her to her heritage, and readied her ear for the blues and jazz, which arose out of the music of the black church. And there were children's and other secular songs Chloe learned, songs her mother had known since she was a child—like the ditty that began: "Green, the only son of Solomon." It was a song Chloe never forgot.

All this folklore seemed on the surface to be merely entertainment, but these stories and songs carried messages about morals and survival, and lessons on African-American ways of life and creativity.

Along with an appreciation for oral traditions, Chloe's parents encouraged her to love the written word. When she entered the first grade she already knew how to read, and as her skills improved she read more and more. As a teenager she devoured whatever books were available to her. France's Gustave Flaubert and England's Jane Austen were among her favorite authors. She had a particular passion for Russian novelists Fyodor Dostoyevsky, author of the classics *The*

*Brothers Karamazov* and *Crime and Punishment*, and Leo Tolstoy, whose masterpieces include *War and Peace* and *Anna Karenina*. What was this African-American girl's fascination with these epics of another culture?

Crossing into another culture was no problem for her because she lived among and went to school with Greeks, Italians, and other European immigrants. But what kept her spellbound about these European writers was the depth and the detail of their writing. Years after she had become an established author she'd reflect:

> *Those books were not written for a little black girl in Lorain, Ohio but they were so magnificently done that I got them anyway—they spoke directly to me out of their own specificity.*

The way Dostoyevsky and others wrote about their people, so richly, would remain vivid in this young reader's mind. It was not only their gift at specificity that absorbed her. As her own novels clearly show, she was attracted to their handling of the tragic things of life.

After graduating with honors from Lorain High School in 1949, Chloe Anthony Wofford attended one of the most highly regarded historically black colleges, Howard University, in Washington, D.C. Here, she majored in English and minored in classics; and here is

where she began to call herself Toni, the shortened form of her middle name Anthony.

As a member of the university's theater group, the Howard Players, she traveled to the South several times where she witnessed what her parents and grandparents had told her about: the bleak and brutal life of so many of her people. She encountered, too, many aspects of black culture with which she was raised. It was quite an experience to see for herself the negative and positive ties that bound African Americans together, North and South. All of this would be more grist for her writing mill.

Though she dabbled in writing as a young woman, it would not be until many years later that this mill would really produce: not until after she had attended Cornell University, where she earned her master's degree in English; not until after she had taught at Texas Southern University in the mid-1950s, and in the late 1950s and early 1960s at Howard University where her mentors included Claude Brown, who became famous for his autobiography *Manchild in the Promised Land.* In 1958 she married a Jamaican architect named Harold Morrison, and soon had two sons, Harold Ford and Slade Kevin. They divorced in 1964. In 1966 Toni Morrison entered a new career when she took a job as an associate editor at a textbook

publishing company in Syracuse, New York. It was during these days that she began to let the writer in her come out more and more. Even then, she did not have her eyes on any literary prizes. As she told one interviewer:

> It wasn't really writing, it was sort of doing something at night, rather than cultivating friendships. I found myself very good company, so I never needed a party or a dinner in order to make me wonder on Saturday night, what are you going to do? And besides I had these little children, and so I wrote at night, sporadically, trying to build a story I had written years [before].

The story she had written years before became *The Bluest Eye*, published in 1970. At the center of this small but powerful novel set in Morrison's hometown in the early 1940s is a poor, lonely, "ugly" girl named Pecola Breedlove, who is abused almost every way imaginable. Moreover, she has the idea that everything would be all right with her and her world if only she had blue eyes. The result of her abuse, neglect, and self-hatred is madness. Eleven-year-old Pecola's madness is complete when she comes to believe that a miracle has occurred—that she now has those precious blue eyes. Near the end of the novel the narrator,

Pecola's former schoolmate and one-time buddy, tells us:

> So it was.
>
> A little black girl yearns for the blue eyes of a little white girl, and the horror at the heart of her yearning is exceeded only by the evil of fulfillment. . . .
>
> The damage done was total. She spent her days, her tendril, sap-green days, walking up and down, up and down, her head jerking to the beat of a drummer so distant only she could hear. Elbows bent, hands on shoulders, she flailed her arms like a bird in an eternal, grotesquely futile effort to fly. Beating the air, a winged but grounded bird, intent on the blue void it could not reach—could not even see—but which filled the valleys of the mind.

What moved Morrison to create such a sorrowful portrait? She drew it from life. As a child she had known a girl who had given up on God because for two years she had prayed for blue eyes and her prayer had not been answered.

In a 1993 television interview, Morrison recalled that what she had done in *The Bluest Eye* was write the kind of book that she had wanted to read—a book "in which black girls were center stage." She was at the time also wrestling with a heavy question: "How does a

child learn self-loathing . . . ? Who enables it? . . . And what might be the consequences?"

One of the consequences of Morrison's wrestlings with these questions was that *The Bluest Eye* showed that this first-time novelist was no run-of-the-mill writer. She was a prober, a listener, a true thinker. The notice that *The Bluest Eye* attracted was without question a result of Morrison's talent, but it was also a sign of the times.

The earliest known piece of African-American writing is "Bars Fight," written in 1746, by sixteen-year-old Lucy Terry, who was kidnapped from Africa as a child and sold to a man in Deerfield, Rhode Island. Phillis Wheatley's *Poems on Various Subjects: Religious and Moral*, which came out in England in 1773, was the first book by an African American to be published. Harriet E. Wilson's *Our Nig; or Sketches From the Life of a Free Black*, was the first novel by an African American to be published in the United States (1859). In the years and decades to come, streams of African-American women would be writing, everything from poetry and plays to short stories and novels. Their works were, however, with a few exceptions, ignored.

This would begin to change in the late 1960s. As a result of the demands made and the enlightenment

gained from the civil rights, black power, and women's movements, a host of publishing companies decided to publish more of these voices, these perspectives. The year that *The Bluest Eye* was published, so was the landmark anthology *The Black Woman*, edited by Toni Cade (Bambara), and Maya Angelou's *I Know Why the Caged Bird Sings*. Morrison was thus one of the brightest lights in the emergence of African-American women writers. Though this phenomenon had much to do with the attention her first novel received, it was her talent that kept readers and critics looking for her next book.

Morrison riveted them with *Sula*, which came out in 1974. It is another story of a woman's search for self, set in Medallion, a fictional Midwestern town. The main character is an extremely bright, extremely brazen, bizarre woman whose neighbors deem her the essence of evil. The novel revolves around a friendship between Sula and another woman named Nel, who is a model of goodness.

Morrison's third novel, *Song of Solomon* (1977), renders the life and times of a Michigan-born young man, Milkman Dead, who is the only son of a very wealthy man, and the great-grandson of a slave named Solomon who, according to legend, escaped bondage by flying back to Africa. This young man must discover his heritage to find his identity and fulfill his

destiny; he is challenged to make a great leap from where he is (selfish, self-indulgent) to what he can become (heroic). What was Morrison aiming at? As she explained to one interviewer:

> Song of Solomon *was about this sort of political problem that young adults have, which is trying to combine upward mobility—middle class, bourgeois, upward mobility— with some kind of respect and reverence for their ancestors. There's always this conflict, as though if you go to college, you can't go back to Lorain, Ohio; or if you stay in Lorain, Ohio, you have to despise everybody who went on. Not quite that simple, but you understand what that tension is. So I was trying to figure out how somebody who's in his late 20s or 30s got educated . . . and what would help inform him to learn how to be a complete human being, without these conflicts, without these self-destructive impulses for material things.*

At the end of the novel, Milkman Dead does indeed find himself; and at the close, he's taking off. To fly.

*Song of Solomon*, so rich with strands of the supernatural, the impossible, made readers await Morrison's next creation.

It was *Tar Baby* (1981), with a journey to a fictional island in the Caribbean for a story about racism,

sexism, and class and color prejudice that spirals out of a romance between Jade, a fashion model, and Son, a rascal-rover.

From this modern-day love story Morrison journeyed back in time to the days of slavery and the Civil War with *Beloved* (1987), which revolves around the hauntings of a child whose mother killed her—not because she did not love her, but because she wanted to save her from slavery. Morrison did not hit a more upbeat note in 1992 with her sixth novel, *Jazz*, which is set in Harlem of the 1920s, and which is structured and sounds very much like the music after which it was titled. The main players are Violet and Joe Trace, a middle-aged couple too tired and twisted by their life experiences to make a happy home.

Morrison's novels give people much to think about. "I did not want to write books that had simpleminded points," she once said. "I wanted to explore the imagination as well as the problems of black people."

In her explorations Morrison's work is heavy with trials and tragedies. There is, however, also within it celebration of the survival of her people and so many of their positive lifeways. Deep within, as well, her novels contain telltale signs of the importance of individual responsibility, and the role of community in the

healing of personal and racial pain. This is in keeping with her vision of fiction:

> It should be beautiful, and powerful, but it should also <u>work</u>. It should have something in it that enlightens; something in it that opens the door and points the way. Something in it that suggests what the conflicts are, what the problems are. But it need not solve those problems because it is not a case study, it is not a recipe.

When one interviewer asked Morrison what she felt was distinctive about her fiction, she replied:

> The language, only the language. The language must be careful and must appear effortless. It must not sweat. It must suggest and be provocative at the same time. It is the thing that black people love so much—the saying of words, holding them on the tongue, experimenting with them. It's a love, a passion.

And Morrison admits how challenging it is to work the language. "Anybody can think up a story," she noted in an interview with Claudia Tate for the book *Black Women Writers at Work*. The hard part?

> But trying to breathe life into characters, allow them space, make them people whom I care about is hard. I only have

*twenty-six letters of the alphabet; I don't have color or music. I must use my craft to make the reader see the colors and hear the sounds.*

Later in the conversation she made this point:

*My writing expects, demands participatory reading, and that I think is what literature is supposed to do. It's not just about telling the story; it's about involving the reader. The reader supplies the emotions. The reader supplies even some of the color, some of the sound. My language has to have holes and spaces so the reader can come into it. He or she can feel something visceral, see something striking. Then we [you, the reader, and I, the author] come together to make this book, to feel this experience.*

Morrison's word-weaving does not make for light and easy reading. What it does make for are adventures. In language. In giant experiences. These adventures are steeped in black history, black folklore, and the moves of black music. They flow with traditional black speech, vision, and ways of knowing. As a result, her novels are not merely good stories, but cultural experiences. For black readers they are a reminder of whence they have come, what they have endured, what they have created. For nonblack readers, *The Bluest Eye, Sula, Song of Solomon, Tar Baby, Beloved,* and *Jazz* are

windows into the lives and losses of people whom the demands and duties of racism have prevented others from knowing.

The greater part of Morrison's contribution to the literary landscape has been her writing of fiction. But she has not limited herself to this. Along with numerous essays, articles, and reviews, her other works include *Dreaming Emmett*, a play (first produced in 1986) inspired by what happened in the summer of 1955 to Emmett Till, a fourteen-year-old Chicagoan who, while visiting with relatives in Money, Mississippi, was lynched because a white man thought he had gotten fresh with a white woman. There's also *Race-ing Justice, En-Gendering Power: Essays on Anita Hill, Clarence Thomas, and the Construction of Social Reality*, a collection of essays by key thinkers published in 1992. That same year a book more directly connected to her first love was published: *Playing in the Dark: Whiteness and the Literary Imagination*, a meditation on the portrayal and influence of black life on the works of such literary greats as Ernest Hemingway, Willa Cather, Saul Bellow, and Herman Melville.

Writing is not the only realm of the literary world where Morrison has had an impact. In 1967 she accepted the position as senior editor at Random House in New York City. There, she called for and shepherded

significant books on the black experience. She not only lobbied for their publication, she also put in long hours in helping the writers produce the best books they could.

*The Black Book* (1974), a pictorial survey of black life and culture from slavery onward, is among the several important works she edited. She championed the project because she saw the need for a book that spoke of ordinary, everyday people and of experiences and facts not usually recorded in history books—a book, as Morrison said, "that simply recorded life as lived." This assemblage of newspaper clippings, sheet music, bills of sale, and other memorabilia came mostly from the collections of the four people who compiled the book, with some items—things stored and forgotten in attics and trunks—supplied by other people, including Morrison.

Novelists and short story writers Toni Cade Bambara and Gayl Jones, and activist Angela Davis are among those whose books might never have seen the light of day were it not for Morrison. As an editor, she also mentored younger black men and women beginning to make careers in the editorial and marketing departments of predominantly white publishing companies. Clearly, Morrison's impact on the writing and publishing world has been quite significant.

✳   ✳   ✳

She is deservedly so famous, and to the average on-looker, it might appear as if it was easy. Nothing could be further from the truth. Writing is not easy. Writing is a lonely, sometimes terrifying thing to do. It is very easy to give up. All the while that Morrison was not giving up, she was also raising two sons and working full-time. Even after her writing began to succeed, she continued to work. She did not leave Random House until 1983. During the 1970s and 1980s she also taught creative writing and literature at various colleges, including the State University of New York at Purchase and at Albany, and at Yale University. In 1989 she accepted the position as the Robert F. Goheen Professor in the Humanities at Princeton University, an appointment established to attract a major writer to teach creative writing and other courses.

All that Morrison has accomplished required more than a powerful imagination and intelligence. It took a work ethic and self-discipline. And where did it all come from? Her childhood. In a 1987 interview in *Publishers Weekly*, she gave credit to her parents and her wider circle of kin.

> [I am] very lucky that those requirements were made on us, that there were so many areas of generosities and manners and work and responsibilities that they imposed on us. Approval was not the acquisition of things; approval was given

*for the maturity and the dignity with which one handled oneself. . . . The sense of organized activity, what I thought at that time was burdensome, turns out now to have with it a gift—which is, I never had to be taught how to hold a job, how to make it work, how to handle my time. . . .*

Indeed, Toni Morrison has handled her time very well, very wisely, and very much to the pleasure of literature lovers around the world.

# Mae C. Jemison

Mae Carol Jemison was raised to reach for the stars. Early on in life she was encouraged and challenged to pursue her dreams and explore her curiosities. So it is not at all surprising that she grew up to do remarkable things.

Jemison, the first black woman astronaut, was born on October 17, 1956, in Decatur, Alabama, and did most of her growing up in Chicago, Illinois, where her family moved when she was three years old. Her mother, Dorothy Jemison, an elementary schoolteacher, and her father, Charlie Jemison, a maintenance supervisor at United Charities of Chicago and part-time construction worker, had trekked north in large part because they wanted Mae and her older siblings, Charles and Ada, to get a better education than was available at the time in Decatur.

Civil rights crusaders had scored a major victory in 1954 with the landmark case *Brown v. Board of Education of Topeka*, wherein the segregation of public schools

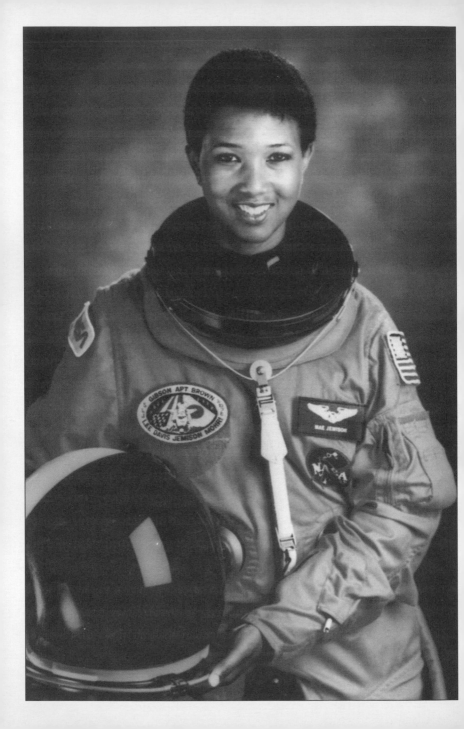

was deemed unconstitutional. The majority of white Southerners—parents, teachers, school administrators, and students, too, were vocally, and sometimes violently, opposed to the ruling. Many school officials responded to the Supreme Court's directive to integrate public schools "with all deliberate speed" with much foot dragging. By the time Decatur's public system changed to obey the Court's ruling, the Jemison children might be almost grown. Understanding that a good education would be Charlie, Ada, and Mae's launching point for being their most productive selves, Mr. and Mrs. Jemison decided not to wait for justice to prevail in Alabama.

One of the best things that ever happened to Mae in the Chicago public school system was her sixth-grade teacher, who took the class on "trips" to various countries in Africa and to other non-European nations most students never studied in those days. This teacher kindled in Mae a passion to know more about the world. Forever, Mae would be eager to learn, especially about the sciences—that field of search and research where the makeup and mysteries of the animal, vegetable, and mineral worlds are explored.

The sciences that held the greatest fascination for Mae were anthropology, archaeology, and astronomy. Anthropology, the study of the origin and development of human beings, would teach her about the

similarities and differences among people around the globe. Archaeology, the investigation of ancient life, would allow her to peep into the changes earthlings and their environment have gone through over thousands and thousands of years. Astronomy taught her about our sun, our moon, our neighboring planets, and other celestial bodies. The wonders she spied through astronomy propelled her to daydream of one day becoming a "star sailor"—the literal translation of the Greek words "astro" and "naut."

Television played a small part in keeping young Mae's hopes up high. In the mid-1960s, when she was around ten years old, along with millions of American youngsters and adults she watched the broadcasts of the flights of *Gemini 3–12* spacecrafts. *Gemini 4*'s particular distinction was that it was on this mission, in June 1965, that an American astronaut, Edward H. White, first walked in space.

Jemison's interest in outer space was also kept alive by a television series that premiered in the fall of 1966. It was *Star Trek*, where week after week, Captain James T. Kirk and crew traipsed the galaxy aboard the starship *Enterprise* on its mission to "explore strange new worlds and seek out new life and new civilizations." For Mae the show's added, very special attraction was the one and only permanent black crew member who was played by Nichelle Nichols. The

member who was played by Nichelle Nichols. The character was the ship's communications officer, Lieutenant Uhura, whose name came from the Kiswahili word for "freedom."

Mae's parents, relatives, and teachers applauded her love of the sciences, encouraging her to read, study, and ask questions. They never had any problem with the fact that two of her favorite places were the Museum of Science and Industry and the Field Museum of Natural History. With all the support she received at home and at school and her natural abilities, she did exceptionally well in school.

As a student at Morgan Park High School Mae was always on the honor roll, and her hard work definitely paid off. She scored so well on the Preliminary Scholastic Aptitude Test (PSAT) that she won a National Achievement Scholarship. Now she could realistically dream of attending one of the top colleges in the country, a school that might otherwise have been out of reach financially. When she graduated from high school in 1973, at the age of sixteen, she began readying herself to further expand her mind at Stanford University in Palo Alto, California.

Whereas most people who graduate from college leave with one degree, at Stanford Jemison fulfilled the requirements for two: chemical engineering and African and African-American studies.

and affirming. It reinforced the fact that there was so much more to black history than slavery and oppression. She was reminded that she sprang from a people who had made important contributions to civilization down through the ages—in the arts, and in the sciences. Her study of the ordeals of her people at home and abroad had a positive effect, too. It reminded her that she came from a strong people.

The strength she gained in her black studies courses made her sturdier for the sometimes rough road she traveled in getting her degree in chemical engineering. The work was not a big problem. Some of her professors were. As J. Alfred Phelps explained in his book *They Had a Dream: The Story of African-American Astronauts,* certain of her teachers "by their very *attitudes* seemed to want to discourage her matriculation as an engineering student."

In the 1970s, far more people than today felt that women and blacks didn't have the "right stuff" for the study of the sciences, let alone to pursue careers in the field. Looking back on those professors at Stanford who scoffed at her ambitions, Jemison remembered:

> *I felt totally invisible. At times, they would look through me. My questions would be handled in a condescending way, and even be ignored, or not answered. It was a new experience for me because I had been used to teachers and*

*professors showing active interest in my quest for knowledge. Additionally, they did show active interest, at least they seemed to, in other students.*

Obviously, for Jemison to have attained two degrees within the same four years meant she had the right stuff, and more. It also meant she had to be a most serious student. But she was not *all* work. She knew how to play. She was very active in the dance and drama groups on campus—as a performer, director, and producer. Her shining achievement was a production of *Purlie*, which she masterminded from start (finding the money) to finish (costumes, lighting, music). In 1976, in her senior year of college, she represented Stanford University at Carifesta, the Caribbean Festival of the Arts held annually in Jamaica.

By the time she graduated from college, Mae C. Jemison was a very well-rounded young woman. She was comfortable in and knowledgeable about the world around her. Her breadth of interests, and her balance, made Jemison a candidate for success in any number of professions. For a time, she thought of becoming a dancer, but in the end, of all the career options available to her the one she chose was medicine. Jemison set her sights on becoming a doctor because she wanted to help people live better and be well.

Cornell University's medical school was where

Jemison decided to go, and on her way to becoming a doctor she was constantly broadening her horizons. In 1979 she led a group to Cuba to study that island-nation's health care system. That same year, with a grant from the International Traveler's Institute for Health Studies, she conducted health care studies in rural Kenya as a member of the "Flying Doctors," as the African Medical Research and Education Foundation was called. During the summer of 1980, Jemison journeyed to Thailand in Southeast Asia. Here, along with other Cornell students, she worked at a clinic in a refugee camp for Cambodians fleeing persecution and starvation in Thailand's next-door neighbor, Kampuchea, as Cambodia was named then.

In her own backyard, Jemison's extracurricular activites included organizing a major health and law fair in New York City for the National Student Medical Association. This event, which took place in 1979, gave people from all walks of life a chance to get free information on a range of medical matters, as well as some minor medical services.

After graduating from Cornell in 1981, Mae C. Jemison, M.D., did her internship at Los Angeles County-University of Southern California Medical College. When she completed this last, and most grueling, leg of medical training she became a general practitioner with INA/Ross Loos Medical Group, in

Los Angeles. But Jemison was not content to stay put.

The combination of her desire to help people and her explorer's spirit prompted Jemison to join the Peace Corps, a government organization started in 1961 by President John F. Kennedy. Its mission was to send volunteers to developing countries in Africa, Asia, the Caribbean, South America, and elsewhere in the world for the purpose of helping their citizens to help themselves in such areas as agriculture, education, and health care.

For two years, from 1983 to 1985, Jemison was stationed in West Africa, serving as Area Peace Corps Medical Officer in Sierra Leone and Liberia. As general manager of the health care system for Peace Corps and U.S. embassy personnel, she not only worked as a doctor, but also ran the laboratory and pharmacy and wrote manuals on health care. In addition, she did research for vaccines for three diseases: rabies (a deadly virus that is most commonly contracted through an animal bite); hepatitis B (a virus that affects the liver); and schistosomiasis (an infection contracted most often through contamined water and snails, which is why it is also known as snail fever).

Without a doubt, Jemison's work was of great benefit to many people, yet she was never one to pat herself on the back. As she candidly told poet Nikki Giovanni in an interview for *Essence* magazine:

> *I've gotten much more out of what I have done than the people I was supposed to be helping. When I was in the refugee camp in Thailand, I learned more about medicine there than I could have in a lifetime somewhere else. I refuse to think those people owe me any thanks. I got a lot out of it.*

When Jemison went back to the United States in 1985, she returned to Los Angeles and the work of a general practitioner at CIGNA Health Plans of California. As happy and excited as she was with the doctoring she did at home and during her travels, she still yearned to do something more, something different. Something out of this world.

Jemison had never abandoned her curiosity about outer space. And now, as a full-grown woman, those childhood daydreams of being a star-sailor did not strike her as so far-fetched. In 1985 she acted on her wishful thinking by applying to the astronaut program at the National Aeronautics Space Administration.

NASA, which runs the United States space program, was launched on October 1, 1958, by President Dwight D. Eisenhower. It had been created to boost the American effort to keep up with, and outrun, the former Soviet Union in the race to explore space. In October 1957, the Soviet Union had launched *Sputnik 1*, the first space capsule, which orbited Earth for 184 days. A few weeks later *Sputnik 2* rocketed up

with life onboard: a dog named Laika. The United States, which did not successfully launch any space capsules until January 1958, did not want to remain in second place.

President John F. Kennedy, who took office in 1961, was passionate about the space program. He worked to make it a number-one national priority. And he succeeded. With government money made abundant for it, and Americans rallying behind the cause, the space race picked up speed: The United States hurried to catch up, while the Soviet Union churned in order not to lose ground.

In April 1961, the Soviet Union's Yuri A. Gagarin became the first human being in space when he orbited Earth for almost two hours in *Vostok 1*. A few weeks later, in the United States, Alan Shepard blasted off on *Liberty Bell*, a fifteen-minute suborbital flight. Then, in February 1962, John Glenn became the first American in space. Glenn's triple orbit of Earth in *Friendship 7* was a milestone in President Kennedy's much grander vision of "landing a man on the Moon and returning him safely to Earth," before the end of the decade. To realize this goal he expanded NASA's facilities. At this time NASA's primary post was the now Kennedy Space Center on Florida's Merritt Island, a few miles north of Cape Canaveral. In 1961 Kennedy gave the go-ahead for construction of the

Manned Spacecraft Center on roughly 1,600 acres of prairie land, located about twenty miles southeast of downtown Houston, Texas. The Manned Spacecraft Center, designed to handle astronaut training and space flight planning and spacecraft development, among other things, opened in September 1963 and would be renamed a decade later as the Lyndon B. Johnson Space Center, in honor of that former president.

President Kennedy lived to see the opening of this new NASA wonder. He did not, however, live to see his larger dream fulfilled. On November 22, 1963, an assassin's bullet brought his life to a halt. But thousands and thousands of Americans were no doubt paying tribute to him and his outer space ambitions on July 20, 1969, when Neil Armstrong stepped out of *Apollo 11* and made history as the first human being to walk on the moon—and to phone home from the moon, with the now-famous report: "Houston . . . The Eagle has landed." After Armstrong's "one small step for man, one giant leap for mankind," as his walk is remembered, NASA rapidly grew and expanded its designs on space exploration, for developing military and civilian technology, for doing medical research, and for just finding out what's out there. At the dawn of the 1970s more and more Americans were thinking of becoming star-sailors.

When Jemison made that move to become an astronaut in the mid-1980s, she represented a definite rarity, as an African American and as a woman. The United States did not have a woman in space until 1983, when Sally Ride rode past the skies in *Challenger*. The Soviets had beaten the United States on this front twenty years earlier, in 1963, when cosmonaut Valentina Tereshkova journeyed starward aboard *Vostok 6*.

As for African Americans as astronauts, that, too, had been a long time coming. Air Force Captain Edward Joseph Dwight, Jr., the first African-American astronaut candidate, left the space program in 1965, after much controversy about his qualifications and treatment, and strong evidence that his career had been sabotaged. Robert H. Lawrence, Jr., an Air Force major, was the first African-American astronaut, but he died in December 1967 when, on a training mission, his jet aircraft, Air Force-104 *Starfighter*, crashed. Given his ranking as an astronaut at the time, he was in line to be a member of the historic *Apollo 11* team, with which the United States first touched down on the moon. Had Lawrence lived, it would have been risky business for NASA to include him on that mission, because although the nation was enthusiastic about having a man on the moon, many would have had a serious problem with that honor being given to an

African American. As one such person put it in a letter to Lawrence's widow, Barbara: "I'm glad he's dead. We don't want no coons on the moon!"

In time, attitudes would improve. However, an African American would not be the first black person in space. That distinction belongs to Arnaldo Tamayo Mendez, an Afro-Cuban who went on a mission for the former Soviet Union in 1980. Three years later, Guion "Guy" S. Bluford, Jr., made his mark as the first African American to journey into space. This flight was on the space shuttle *Challenger*'s third mission, on August 30, 1983.

Jemison was of course aware of a few other African-American star-sailors. Among them was Ronald McNair, who first voyaged aboard the *Challenger* on February 3, 1984, and who, along with his fellow crew members, died aboard *Challenger* when it blew up shortly after liftoff on January 28, 1986. Frederick Drew Gregory was the first African American to pilot a space shuttle (*Challenger* on April 29, 1985); and Charles F. Bolden, Jr., piloted *Columbia* on January 12, 1986.

When Jemison applied to NASA in 1985, she was keenly aware that there had not been many of her race or gender selected as astronauts. She knew the odds, just as she knew of the pressures and harassment experienced by the African Americans and women whose

course she was now charting. But she did not let this stop her. She worked to better her chances at acceptance by broadening her base of knowledge with graduate engineering courses at the University of California.

Clearly, Jemison was very serious about pursuing this dream, but her hopes were put on hold. Along with hundreds of others, her application was scrapped because of the 1986 *Challenger* accident. NASA had put a freeze on the astronaut selection process. When the moratorium was lifted in 1987, Jemison, more aware than ever of the dangers astronauts face, applied again.

Acceptance does not happen immediately. To even be in the running, one must have at least a bachelor's degree in engineering, biological science, physical science, or mathematics, and three years of professional experience. With her degree in chemical engineering and a doctorate of medicine, and with her years of doctoring and the extra engineering courses she now had under her belt, Jemison certainly had the credentials. But so did hundreds of other men and women. Quality credentials was only the first hurdle. Like other applicants, Jemison had to go through a series of interviews to determine whether she was mentally and emotionally fit for astronaut training and, one day, a spaceflight. Physical fitness was a must as well. And how would her personality fit?

It is not enough to be smart and in fine mental and physical shape. NASA wants people who are also well-rounded and who have good people skills. Being able to work well with others is important to keep missions sailing smoothly, and it is doubly important in the event of a crisis. As NASA advises all would-be star sailors: "Astronauts are expected to be team players and highly skilled generalists with just the right amount of individuality and self-reliance to be effective crewmembers."

Had she wanted to be a pilot, Jemison would have to have clocked at least one thousand hours of flying time as pilot-in-command of a jet aircraft. But Jemison was to be a mission specialist. These astronauts work on various facets of shuttle operations, from scheduling work and other activities to keeping the craft up and running. They take EVAs (extravehicular activities), as space walks are known. Their major assignment is to oversee or work on specific experiments conducted during a mission.

In June 1987, out of roughtly two thousand applicants, Mae C. Jemison was one of the fifteen chosen. It was a grand moment for her, but it would be a while before she made history.

Along with other astronaut candidates, Jemison began a one-year term of training and evaluation at the

Johnson Space Center. There was classroom time with oceanography, meteorology, geology, mathematics, guidance and navigation, astronomy, and other courses to study. There was also fieldwork, such as scuba diving and parachute jumping and land-and-sea survival training. And there was time spent just floating around —in microgravity, that is—to prepare her for moving and working in space where what goes up stays up. Jemison also received training in the Space Transportation System (or STS), where she learned all about the ship on which she would fly: how it works and how to fix what might break down.

In August 1988, at the end of her training, Jemison became a full-fledged astronaut. The next step was a mission. And in time, it came.

On September 12, 1992, at Kennedy Space Center's Pad B in Launch Complex 39, Mae C. Jemison, age thirty-six, boarded the space shuttle *Endeavour* as a science mission specialist. Her six space-mates were Robert L. "Hoot" Gibson, Curtis L. Brown, Mark C. Lee, Mamoru Mohri, Jerome "Jay" Apt, and N. Jan Davis. This mission was historic for many reasons. Not only did it have onboard the first black woman astronaut—who was also NASA's first science mission specialist—but Lee and Davis were the first married couple to go on a mission together.

In terms of the bigger picture of space exploration, the flight of *Endeavour* was the first joint mission between the United States and Japan, whose National Space Development Agency was represented by Mamoru Mohri. This cooperative effort was especially significant because *Endeavour's* mission was part of NASA's ultimate goal of establishing an interational space station.

This *Endeavour* flight represented another breakthrough for NASA insiders. Of the many shuttle missions since November 1985, it was the first to leave on time. Liftoff was at 10:23:00 A.M.

When Mae C. Jemison took off for the stars, one Earth memento she took along was the Alvin Ailey American Dance Theater's poster for *Cry*, a dance about the ordeals African-American women have endured and the courage, grace, and dignity so many have displayed. The poster was, for Jemison, a reminder that her people—her womenfolk in particular—were very much citizens of the world. This truth made Jemison impatient with those who questioned a black person's interest in space exploration. As she said to Constance M. Green in an interview for *Ms.* magazine:

> *When I'm asked about the relevance to black people of what I do, I take that as an affront. It presupposes that black people have never been involved in exploring the heavens, but*

*this is not so. Ancient African empires—Mali, Songhay, Egypt—had scientists, astronomers. The fact is that space and its resources belong to all of us, not to any one group.*

Among the other keepsakes Jemison took was a banner of the black sorority Alpha Kappa Alpha, and proclamations from Chicago's public school system and the DuSable Museum of African-American History. When they heard about what Jemison was taking along, some resented her all-black choices. Such people were unable to understand that with her embarking on a potentially very dangerous mission, she needed to be connected with a major source of her strength.

The first "landmark" Jemison saw as she soared was Chicago. As *Endeavour* zoomed higher and higher, she would see all of Earth in its entirety, as a globe. Mae C. Jemison had reached for the stars, and now she was there. Of course, she did not have too much time for stargazing. She was not a tourist, but a science mission specialist. There was work to do.

Of the more than forty experiments conducted aboard *Endeavour*, the one most popular with the press was the one conducted on frogs. The point was to hatch eggs and monitor their development into tadpoles. Months after her return to Earth, Jemison reported that the space-born frogs were doing quite

nicely and were in good condition. During her mission, Jemison also did research on the effects of microgravity on the growth and health of bones. There were also experiments toward preventing and curing space-sickness. In terms of the goals and purpose of these and other experiments, as Jemison once explained, *Endeavour's* science mission was about "trying to figure out how human beings function in space. . . . [and] how to keep people healthy while they're in space."

One hundred and ninety hours, thirty minutes, twenty-three seconds is how much time Jemison spent aboard *Endeavour* as it orbited Earth one hundred twenty-seven times during its eight-day stay in outer space. Touchdown was at 8:53:23 A.M. on September 20, at Kennedy Space Center's Runway 23.

After her historic journey and the numerous awards and honors it brought her, Mae C. Jemison became a celebrity, even doing a part in an episode of *Star Trek: The Next Generation*, which aired in May 1993. Not surprisingly, she became a prominent role model. Though she would certainly never discourage young people from following in her footsteps and pursuing careers in the sciences, she first and foremost encouraged them to pursue their true passions. "Most importantly, pick something you really love and have fun," she once said. "When times get hard, that will give you the energy to keep at it."

*   *   *

In 1993, to the dismay of many, Mae C. Jemison left NASA. She left to explore other possibilities and other ideas that might benefit human beings on Earth and in outer space. Her own company, The Jemison Group, became her base of operations. Its mission: To develop and market advanced technologies and programs to improve the quality of people's lives and minds. Her company's early projects included a satellite-based telecommunication system to improve health care in West Africa and an international science camp for teens named The Earth We Share.

# Jackie Joyner-Kersee

One of the often-told stories about this woman's beginnings is the one about her name. When she was born on March 3, 1962, she was named after the First Lady of the United States at the time: Jacqueline Kennedy, a person of intelligence, grace, and sterling style.

It was the infant's grandmother, Evelyn Joyner, who insisted on the name Jacqueline. Her reasoning? She was certain that "someday this girl will be the first lady of something."

Did Grandma have the gift of prophecy?

We do not know all that Evelyn Joyner saw in her grandbaby, but all the world knows that the child definitely grew up to be "the first lady of something."

The love of sports and the grit and grace to compete were developing when Jackie was quite young. She was nine when she ran her first track meet. Although she came in last, the loss did not devastate her; rather, it fueled her resolve to do better, and better, until after

repeated races she was bringing home first-place prizes.

Home was a plain little house on a mean street in East St. Louis, Illinois. As the authors of the book *American Heroes* put it, "the environment was anything but uplifting." But home was.

Jackie's parents married young and had their first child, Al, when they were teenagers. Jackie came along three years later, when her mother, Mary, was nineteen, and her father, Alfred, was seventeen. Mr. and Mrs. Joyner worked double-time (she as a nurse's assistant, and he as a construction worker and later for the railroad) to provide for their children, instilling in them a zeal to rise above adverse circumstances.

Home was also a few shops away from the Mary Brown Community Center. It was here where Jackie expended her excess energy, which if not channeled into positive action could so easily have drawn her into all kinds of delinquent behavior that was the trademark of many of her neighborhood peers. Swimming and dance lessons were among the center's activities that Jackie enjoyed. It was on the center's track, however, where she most vigorously stretched her legs. Running became her main event. It was at this center where she ran that first track meet. And it was at the center where she first displayed exceptional talent in the long jump.

The Mary Brown Community Center was also where Jackie acquired her first sports mentor. Pop

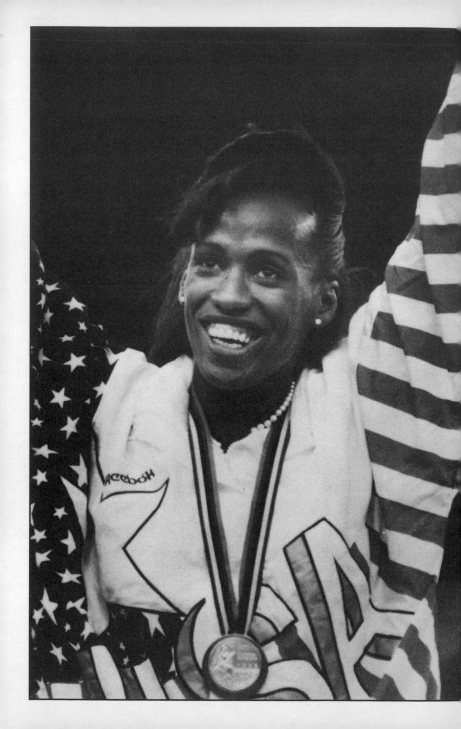

Miles was his name, and he was the man who ran the center. When he noticed Jackie's high athletic aptitude, he had little doubt that she possessed what it would take to one day compete in that grandest of sports fests, the Olympic Games.

The original Games, which started in ancient Greece in 776 B.C. and were played on the plain of Olympia, were part of a religious festival held every four years. At first there was only one event, foot racing, but in time, other field events such as the discus throw were added. In its modern incarnation, which had its debut in Athens, Greece, in 1896, the roster of events would greatly expand, the competitors would come from all around the world, and the Games themselves would be held every four years in a different city on a different continent.

As in ancient times, to be an Olympian in the modern era is a most noble pursuit and a mark of excellence. Pop Miles foresaw that Jackie had the talent and the character to be just such a champion, so he nurtured it and cheered her on. Jackie's sports fever fired her brother, Al, to take his athletic abilities more seriously and begin the work that one day would enable him to make a name for himself in track and field.

Jackie was a name in sports in her early teenage years. When she was fourteen she won the National Junior Pentathlon Championship. This was not the

only time she bested her peers in this five-sport event. She did it again when she was fifteen, when she was sixteen, and when she was seventeen. Another glory from her days as a student at Lincoln High School was setting an Illinois record for the long jump. Jackie also played on her high school's continually winning basketball team.

During her high school days, Jackie's Olympic potential was very apparent. It was tested in the trial games for the 1980 Summer Olympics to be held in Moscow, Russia, then the capital of the former Soviet Union. Jackie more than made the grade, and was made a member of the U.S. Olympic Track-and-Field Team. Unfortunately, being a bona fide Olympian would be a dream deferred: Because of the Soviet Union's invasion of Afghanistan in 1979 and refusal to withdraw, the United States, along with about forty other nations, withdrew from the 1980 Summer Olympic Games. Like hundreds of other athletes, Jackie would have to wait four more years.

In the midst of her athletic success, Jackie was having victories with academics, too. When she graduated from high school she ranked among the top ten percent of her class. She was just the kind of student colleges were eager to have. The one she went to was the University of California at Los Angeles (UCLA), which awarded her a basketball scholarship.

At UCLA Jackie was a real champion on the basket-ball court—a standout forward, and a key player in her team's many wins. Though basketball would forever be her favorite sport, she did not abandon track and field.

In her early days in college, if Jackie had had a weaker constitution she could have abandoned all her interests: Her mother died of meningitis when Jackie was in the middle of her freshman year. This deep loss would give Jackie perspective and enable her to cope better with any losses she might ever suffer in sports. There was not much that could hurt her more than her mother's death. Thus, this tragedy's silver lining was a stronger, more resilient, more persevering Jackie Joyner.

Her all-around athleticism caught the attention of UCLA's assistant track coach, Bob Kersee. After get-ting special permission to work with Jackie, he started coaching her not merely for running and the long jump, but also for the most demanding track-and-field event for women: the seven-sport phenom, the hep-tathlon. This "sister" to the decathlon (ten events for men) is composed of four field events—the high jump, the shot put, the javelin throw, the long jump—and three track events—the 100-meter hurdle, the 200-meter run, the 800-meter run. The total score for this two-day event determines the winner. An athlete who can master all these events is a superb athlete

because of the multiplicity of abilities it requires: speed, endurance, flexibility, power, coordination.

In 1982 and 1983 Jackie showed that being a heptathlete was more than a notion. She was a wonder on the college heptathlon circuit, setting new records and outdoing herself every step, leap, throw, hurdle, dash, and run of the way. Because of her prodigious talent she was chosen to compete in the 1983 World Track-and-Field Championship, held in Helsinki, Finland, that year. Her brother, Al, who had become a track star at Arkansas State University, was chosen, too. Everyone expected a great performance from Jackie, but, sadly, a pulled hamstring, her first major injury, prevented her from competing at full capacity.

Jackie wasn't out of the running for the trial games for the 1984 Summer Olympic Games. Once again she made the nation's track-and-field team. Luckily for her, the Games were being held in Los Angeles. Another wonderful aspect of the event was that her brother was also a member of the U.S. Olympic Track-and-Field Team.

In the Olympic trials Jackie had set a new American heptathlon record when she scored 6,520 points. However, at the Olympics, she did not outdo herself: She scored 6,385 points—just five points less than Australia's Glynnis Nunn, just six points away from getting the gold medal. Her winning a silver medal

for second place is hardly a small achievement. Not only was it a major feat, but in this case it was extra special because with it Jackie became the first American woman to win an Olympic medal for a multiple-event competition. Jackie's fans, and the young woman herself, must have thought about what she might have scored had she been in perfect condition. She had again suffered a pulled hamstring during the competition. Due to this injury, her best event, the long jump, suffered. The hamstring pull also hampered her speed in the final event, the 800-meter run.

One of the all-time heartwarming sights in track and field was her run of the final lap, when her brother ran alongside her, encouraging her on. "Pump your arms!" Al shouted to help her keep going. "This is it!" he yelled to help his sister push past the pain. Jackie Joyner's performance was memorable; she was only six seconds too slow.

In addition to a silver medal, Jackie had what you might call a secondhand victory when, several hours after her 800-meter run, Al won a gold medal for the triple jump. This was the first time a brother and sister had won Olympic medals on the very same day. At this, the Twenty-Third Olympiad, Jackie had a lot to celebrate. This U.S. Olympic Track-and-Field Team was the best the world had ever seen, racking up fifty-one medals. As she cheered her team members on,

Jackie understandably had some super cheers for her fellow African Americans. A record-breaking twenty-six African Americans won forty-one of the medals. This was the Olympic Games in which Carl Lewis won four gold medals, Valerie Brisco-Hooks won three, and Evelyn Ashford won two. It was also where the snazzily attired, flamboyant Florence Griffith—soon to be known as "Flo Jo"—won a silver medal. Being in the company of such athletes as these, on top of her triumph, was certainly a peak moment for twenty-two-year-old Jackie Joyner. But she would go higher. Her first Olympics was not to be her last.

As she waited and readied herself for the next Summer Olympics, Jackie Joyner outdid herself in several national and international competitions, most notably at the 1986 Goodwill Games in Moscow, created to ease tension between the United States and the former Soviet Union. Here, Jackie set a new world record when she racked up 7,000 points. From here on she would consistently crack the 7,000-point mark.

Nineteen eighty-six was a banner year for Jackie. Not long after the Goodwill Games, following her performance at the U.S. Olympic Festival, in Houston, Texas, she was given the Sullivan Award, which named her the top amateur athlete across the sports spectrum. Another precious prize for Jackie Joyner was the Jesse

Owens Award, for outstanding achievement in track and field (an award she'd receive again in 1987). The most wonderful event of the year, however, was her marriage to her coach, Bob Kersee.

In 1987 Jackie amazed sports lovers again with her performances in the Pan American Games, held close to home, in Indianapolis, Indiana. Then, across the Atlantic Ocean, in Rome, at the World Track-and-Field Championship, she won two gold medals: one for the long jump and the other for her steady standard, the heptathlon.

And then . . . another Summer Olympics was upon her.

The place was Seoul, South Korea. One of the personal highlights here for Jackie was that Flo Jo, by then married to Al Joyner, was competing and would win three gold medals (for the 100-meter run, the 200-meter run, the 4 x 100-meter relay), and a silver (for the 4 x 400-meter relay). As for the five foot ten inch, 145-pound Jackie Joyner-Kersee, she was a double gold medalist: winning one for the long jump—a 24-foot $3\frac{1}{4}$-inch leap that set a new Olympic record, and one for the heptathlon, where she set a new world record with her 7,291 points. Could she get any better than this?

In the 1992 Summer Olympics, held in Barcelona,

Spain, though Jackie's long jump netted her a bronze medal, the gold medal was once again hers for the hep-tathlon. She was now thirty years old and the first woman in the world to win back-to-back Olympic gold medals in a multiple-event competition. Immedi-ately, she was looking ahead to the next Summer Olympics. Right after her heptathlon victory, she mused, "Wouldn't it be great to complete my career back on American soil, in Atlanta in 1996?"

Among her post-1992 Olympics honors was be-ing named Amateur Sportswoman of the Year by the Women's Sports Foundation. She also became busier and more well-known through product endorsements and hosting shows about youth-related issues. As for her athletic endeavors, these included the World Track-and-Field Championship in Stuttgart, Germany, in 1993, which she entered on the heels of another in-jury, and where she won the gold.

Another memorable competition was the 1994 New York Games. The event took place not long after the death of the woman after whom she had been named, Jacqueline Kennedy Onassis. In addition to honoring the former First Lady with kind words, Jackie Joyner-Kersee also dedicated her long jump to her. And with the jump she set a new American record of 24 feet 7 inches.

Her medals and her awards are many. Her place in

the history books as a first lady of track and field—
and as one of the greatest athletes of all time, male or
female—is secure. Yet, it is not unreasonable for even
the most loyal fans to stop and ask: What is so daring
about what Jackie Joyner-Kersee has done? Indeed, she
was no pioneer in terms of black participation in orga-
nized track-and-field competitions, for such has been
going on since the late 1900s. Though notions about
women and sports for a long time barred women from
premier track-and-field competitions, Jackie Joyner-
Kersee broke no barriers in this regard.

Jackie Joyner-Kersee was not the first black track
and fielder to reach for the Olympics. Among her
many forerunners are George Poage, who competed in
the 1904 Olympics; John Baxter Taylor, winner of a
gold in the 1908 Olympics; and, of course, there was
Jesse Owens, who, much to the fury of Adolf Hitler,
won four gold medals at the 1936 Olympics in
Germany. Had Jackie Joyner-Kersee needed any
African-American female role models, she could look
back with great pride at such trailblazers as Alice
Coachman, the first black woman to win an Olympic
gold medal for the long jump in 1948; Wilma
Rudolph, winner of a bronze medal in 1956 and a
triple gold medalist in 1960; and Wyomia Tyus, whose
four medals include two golds, in 1964 and 1968.

Part of Jackie Joyner-Kersee's daring, as with other

athletes, lies in the stamina to run the course required to be a true champion, managing that thin line between pushing oneself past the pain and past the fear of failure, and pushing oneself over the edge. It takes a lot of guts to remain committed to the intense training required to become a first-rate athlete. And in an athlete's pursuit of excellence, there's always the possibility, with one uneven or too-swift move, of a serious injury.

Jackie Joyner-Kersee has been daring in taking up the challenge to reach for success above and beyond what she knew she could do. She could have focused on one sport only—the long jump, for instance—and she would have become a champion at that. But she dared to pursue the heptathlon, which would require so much more of her in terms of time and training. And then, there's the asthma from which she has suffered since she was a child.

No less daunting and praiseworthy is Jackie Joyner-Kersee's stamina to not become frivolous in the wake of her fame. She has always been far more interested in giving back than in being a self-absorbed celebrity. With her victories, product endorsements and other moneymaking opportunities have come her way, and instead of lavishing on herself all the material things her riches could buy, she translated a significant

amount of her money into opportunities for others. This has been in keeping with one of her mottoes:

*There's more to life than competing. If I can cheer someone on, I'm willing to do that.*

Jackie Joyner-Kersee has cheered many young people on in very concrete ways. Tuition assistance to students bound for college or a vocational/trade school is just one of the ways. The annual JJK Relays in East St. Louis, which includes a "Winning in Life" motivational session, gives young ladies a chance to engage in a track and field competition as well as meet top athletes from around the world. One of Joyner-Kersee's most outstanding expressions of love and concern for the young people in her hometown is the Jackie Joyner-Kersee Youth Center Foundation. In the mid-1990s, the Foundation began laying plans for a state-of-the-art multi-purpose recreation and education facility in East St. Louis to fill the void left by the closing of the Mary Brown Center where Jackie Joyner-Kersee got her athletic start.

As the 1996 Summer Olympics in Atlanta, Georgia, drew near, many wondered how much longer Jackie Joyner-Kersee's track-and-field career would last. At the trials she did not finish first in the heptathlon as most

expected, but second. "Sometimes it doesn't go your way," she remarked. "That doesn't mean to me that I should quit or I should give up." But things continued not to go her way. That recurrent hamstring injury mangled her steps to victory during the Games. She was far from spectacular in the hurdles race, stumbling after the tenth and last hurdle, limping across the finish line with the power of the pain evident on her face. A little over an hour later she returned to the field to ready herself for the next heptathlon event, the high jump. However, after a few practice jumps Joyner-Kersee left the field, leaving behind her hopes of becoming a three-time multievent Olympian.

She had withdrawn from the heptathlon, but not from the Olympic Games altogether. A few days later, with her right thigh bandaged, she entered the long jump competition. Her fans were aching for her each time she ran the distance to the board and took a jump, deeply saddened that before her sixth and final jump she was in sixth place. But, oh, how they cheered that last jump of 22 feet and $11\frac{3}{4}$ inches. With it, though she did not win the gold or the silver, Jackie Joyner-Kersee did win a bronze, thereby completing her career "on American soil" with at least one medal.

"Of all the medals I've won," she said afterward, "this one is special because I really had to work for it."

# And Some Others Who Dared

**Nancy Prosser** (c. 1770–?): She did not want to die enslaved on a plantation near Richmond, Virginia, so she joined her husband, Gabriel Prosser, in planning a revolt and recruiting other men and women to join in the uprising, set for August 30, 1800. Though the revolt was crushed immediately, the Prossers inspired other uprisings.

**Sojourner Truth** (1797–1883): This mighty woman, once enslaved in Ulster County, New York, lectured boldly for the cause of abolition throughout the Northeast and Midwest. After her emancipation under New York State law in 1827, she traveled around the nation preaching the rightness of equal opportunity for people of African descent and women.

**Harriet Tubman** (c. 1820–1913): In 1849 she escaped slavery on a Maryland plantation, and during

the next ten years, she returned to the South numerous times, leading more than three hundred men, women, and children to freedom. This conductor on the Underground Railroad was called "Moses" by her people. During the Civil War, Tubman contributed to the freedom cause by serving as cook, nurse, and scout for the Union army, helping to plan and lead several raids on Confederate strongholds.

**Mary Ann Shadd Cary** (1823–1893): This freeborn woman from Wilmington, Delaware, was fearless in her denunciation of slavery and discrimination. In the early 1850s, she moved to Canada, where she started the *Provincial Freeman*, becoming the first woman of African descent to own and operate a newspaper in North America. The *Provincial Freeman's* main mission was to urge blacks, runaways, and the free, to move to Canada, where they could enjoy more liberty. The paper's motto was "Self-reliance is the true road to independence."

**Mary Elizabeth Bowser** (1839–?): Born outside of Richmond, Virginia, this former slave became a most effective spy for the Union army. Her "superior officer" was Elizabeth Van Lew, the daughter of her former owner. (Bowser was freed upon his death in

1851.) "Crazy Bet," as Van Lew was known, managed to get Bowser working as a servant at the Confederate White House. Pretending to be a good but rather daft servant, Bowser eavesdropped on the President of the Confederacy, Jefferson Davis, and others. When she could she went to Van Lew's house and repeated all the military plans and other information she had memorized. Bowser's findings were passed on to General Grant, and proved very useful in Yankee campaigns.

**Susan McKinney Steward** (1847–1918): This pioneer in medicine was prompted to go to medical school in part because of the lives lost in her hometown of Brooklyn, New York, during a cholera epidemic in 1866. After graduating in 1870 from New York Medical College for Women, Steward became the third African-American female physician. For many years she maintained a successful practice in Brooklyn, where she cofounded a women's hospital.

**Madame C. J. Walker** (1867–1919): In the early 1900s, this former washerwoman, born Sarah Breedlove, began selling her hair-care products door-to-door. In a few years' time, she was on her way to becoming a millionaire. Her empire, which would include a large line of beauty products, beauty schools, beauty

parlors, and a manufacturing plant, provided jobs for thousands of people, mostly women.

**Maggie Lena Walker** (1867–1934): In 1903 she became the first woman to open a bank in the United States: the Saint Luke Penny Thrift Savings Bank in Richmond, Virginia, which later became the Consolidated Bank and Trust Company.

**Bessie Coleman** (1893–1926): When aviation schools in the United States denied her admittance, she set sail for Europe in 1920 and studied in Paris, France. Upon her return to the United States, this first black woman to earn a pilot's license began a thrilling career as an exhibition flyer, and soon made plans to open an aviation school. Sadly, "Queen Bess" fell out of her plane — at two thousand feet above ground — during a rehearsal for an air show in Jacksonville, Florida.

**Pauli Murray** (1910–1985): Born in Baltimore, Maryland, she fought Jim Crow in the 1930s and 1940s in North Carolina and other states, using her legal wit and often such nonviolent tactics as sit-ins. Murray was the first black person to earn a doctorate of juridical science from Yale University Law School (1965), a founding member of the National

Organization for Women (1966), and the first black woman priest of the Episcopal Church (1977).

**Rosa Parks** (1913– ): Her refusal, on December 1, 1955, to surrender her seat to a white person and her subsequent arrest was one of the sparks for the 381-day bus boycott in Montgomery, Alabama, which was led by Martin Luther King, Jr., and resulted in the outlawing of segregation on public buses.

**Gwendolyn Brooks** (1917– ): As a child growing up in Topeka, Kansas, she took great pride in the poetry she wrote. In 1950 Brooks became the first African American to win the Pulitzer Prize for poetry, which she received for her first collection of verse, *Annie Allen*. Some of her later honors are: poet laureate of Illinois from 1968 to 1984, and poetry consultant to the Library of Congress from 1985 to 1986. Brooks has written more than a dozen books, most of which are poetry and several of which are for young people.

**Fannie Lou Hamer** (1917–1977): In the early 1960s, this sharecropper from Ruleville, Mississippi, was involved in the voter registration campaign. She suffered continual harassment by the police and other white citizens who did not want African Americans to vote.

Hamer, however, did not grow weary of rallying people in her community to exercise this right. Her other civil rights work includes founding the Mississippi Freedom Democratic Party.

**Daisy Bates** (1920– ): With her husband, she started the weekly newspaper the *Arkansas State Press*, in 1941, which advanced the civil rights cause. In the early 1950s, Bates became president of the Arkansas NAACP and, in 1957, led the battle to desegregate Central High School, in Little Rock, Arkansas, and so became known as the "Mother" of the "Little Rock Nine," the band of brave teenagers — six girls and three boys — who tried to desegregate the school.

**Constance Baker Motley** (1921– ): Graduating from Columbia Law School in the mid-1940s, she honed her skills with the NAACP Legal Defense and Education Fund, where she worked closely with Thurgood Marshall. She played an important role in the *Brown v. Board of Education of Topeka* case, and served as chief legal counsel to James Meredith and Charlayne Hunter-Gault and several other young men and women fighting for entry into segregated colleges in the South. Motley became the first African-American woman federal judge when, in 1966, President Lyndon Johnson appointed her to the United States District Court for the Southern District of New York.

**Ruby Dee** (1924–    ): Beginning with her role of Kate in *The Taming of the Shrew,* in 1965, she was the first black woman to play major parts with the American Shakespeare Festival at Stratford, Connecticut. Her many film and play credits include *A Raisin in the Sun, Purlie Victorious, Wedding Band,* and *Do the Right Thing.* Along with her husband, actor-writer-director Ossie Davis, Dee has always been politically active, even when speaking out about how injustices hurt her career.

**Shirley Chisholm** (1924–    ): The first African-American woman elected to the U.S. Congress, she held the seat for the 12th Congressional District of Brooklyn from 1968 to 1982, and made more history in 1972 with the words "I declare myself a candidate for the President of the United States of America." Though this Democrat did not win her party's nomination, she kept issues of particular interest to black people and women from being totally ignored. She founded and chaired the National Political Congress of Black Women.

**Althea Gibson** (1927–    ): She was to professional tennis what Jackie Robinson was to major league baseball: a color-barrier breaker. She grew up to be the first African American to play at the U.S. Open at Forest Hills, New York (1950), and at Wimbledon, England

(1951). In 1957 Gibson became the first black tennis player to win Wimbledon. *I Always Wanted to Be Somebody* is the title of her autobiography.

**Marva Collins** (1936–   ): In 1975 this veteran public schoolteacher used her own money to open a school in her home, Westside Preparatory, which specialized in making winners out of students the public school system labeled losers.

**Wilma Rudolph** (1940–1994): By age four, she had been stricken with scarlet fever; twice with double pneumonia; and with polio, which left her left leg useless. But Wilma Rudolph grew up to be a sports wonder. In the 1960 Summer Olympic Games she won three gold medals: for the 100-meter dash, the 200-meter dash, and the 400-meter relay.

**Charlayne Hunter-Gault** (1942–   ): In 1961, when she was eighteen years old, she and another student, Hamilton Holmes, became the first blacks to attend the University of Georgia, in Athens. This young newsmaker went on to become an award-winning print and broadcast journalist. She has shared the substance of her life in the book *In My Place*.

# Selected Bibliography

Craft, William. *Running a Thousand Miles for Freedom.* 1860. Reprint. New York: Arno Press, 1975.

DeCosta-Willis, Miriam, ed. *The Memphis Diary of Ida B. Wells.* Boston: Beacon Press, 1995.

Duster, Alfreda, ed. *Crusade for Justice: The Autobiography of Ida B. Wells.* Chicago: Unviersity of Chicago Press, 1970.

Franklin, John Hope, and August Meier, eds. *Black Leaders of the Twentieth Century.* Chicago: University of Illinois Press, 1982.

Franklin, John Hope, and Alfred A. Moss, Jr. *From Slavery to Freedom: A History of Negro Americans,* sixth ed. New York: Knopf, 1988.

Gates, Henry Louis, Jr., and K. A. Appiah, eds. *Toni Morrison: Critical Perspectives Past and Present.* New York: Amistad Press, 1993.

Giddings, Paula. *When and Where I Enter: The Impact of Black Women on Race and Sex in America.* New York: William Morrow, 1984; Bantam, 1985.

Ginzburg, Ralph, ed. *100 Years of Lynchings.* 1962. Reprint. Baltimore: Black Classic Press, 1988.

Hale, Lorraine E. *Hale House: Alive With Love.* 1991. Reprint. New York: Hale House, 1992.

Hine, Darlene Clark, ed. *Black Women in America: An Historical Encyclopedia.* Brooklyn, NY: Carlson Publishing, 1993.

Horton, James Oliver. *Free People of Color: Inside the African American Community.* Washington, D.C.: Smithsonian Institution Press, 1993.

Hughes, Langston, Milton Meltzer, and C. Eric Lincoln. *A Pictorial History of Blackamericans,* 5th ed. New York: Crown, 1983.

Katz, William Loren. *Black People Who Made the Old West.* Trenton, NJ: Africa World Press, 1992.

Lanker, Brian. *I Dream a World: Portraits of Black Women Who Changed America.* New York: Stewart, Tabori & Chang, 1989.

Phelps, J. Alfred. *They Had a Dream: The Story of African-American Astronauts.* Novato, CA: Presidio Press, 1994.

Salem, Dorothy C., ed. *African American Women: A Biographical Dictionary.* New York: Garland, 1993.

Smith, Jessie Carney, ed. *Notable Black American Women.* Detroit: Gale Research, 1992.

Sterling, Dorothy. *Black Foremothers: Three Lives,* second ed. New York: The Feminist Press, 1988.

Stevenson, Brenda, ed. *The Journals of Charlotte Forten Grimké.* New York: Oxford University Press, 1988.

Story, Rosalyn M. *And So I Sing: African-American Divas of Opera and Concert.* 1990. Reprint. New York: Amistad Press, 1993.

# Index